Painting Skies
and Seascapes

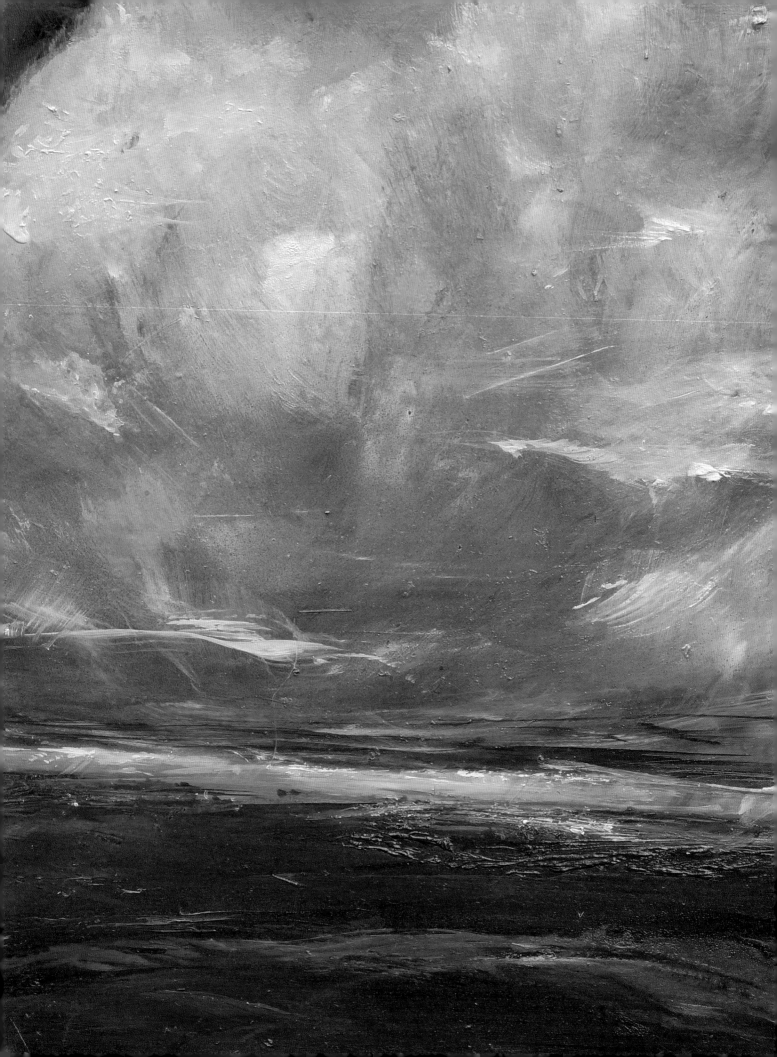

Painting Skies and Seascapes

Peter Rush

THE CROWOOD PRESS

First published in 2014 by
The Crowood Press Ltd
Ramsbury, Marlborough
Wiltshire SN8 2HR

www.crowood.com

British Library Cataloguing-in-Publication Data
A catalogue record for this book is available from the British Library.

ISBN 978 1 84797 621 5

All illustrations by the author, except where otherwise credited.

Typeset by SR Nova Pvt Ltd., Bangalore, India
Printed and bound in India by Replika Press Pvt Ltd

CONTENTS

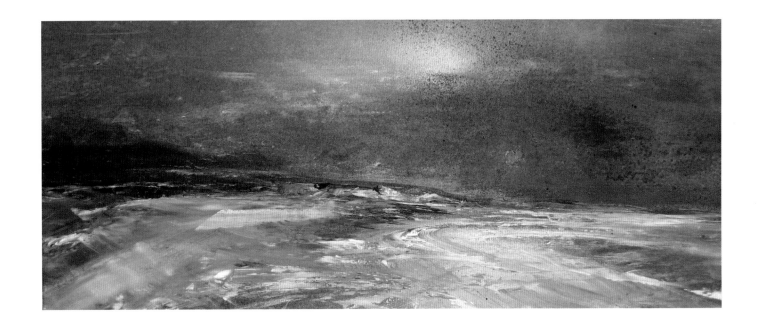

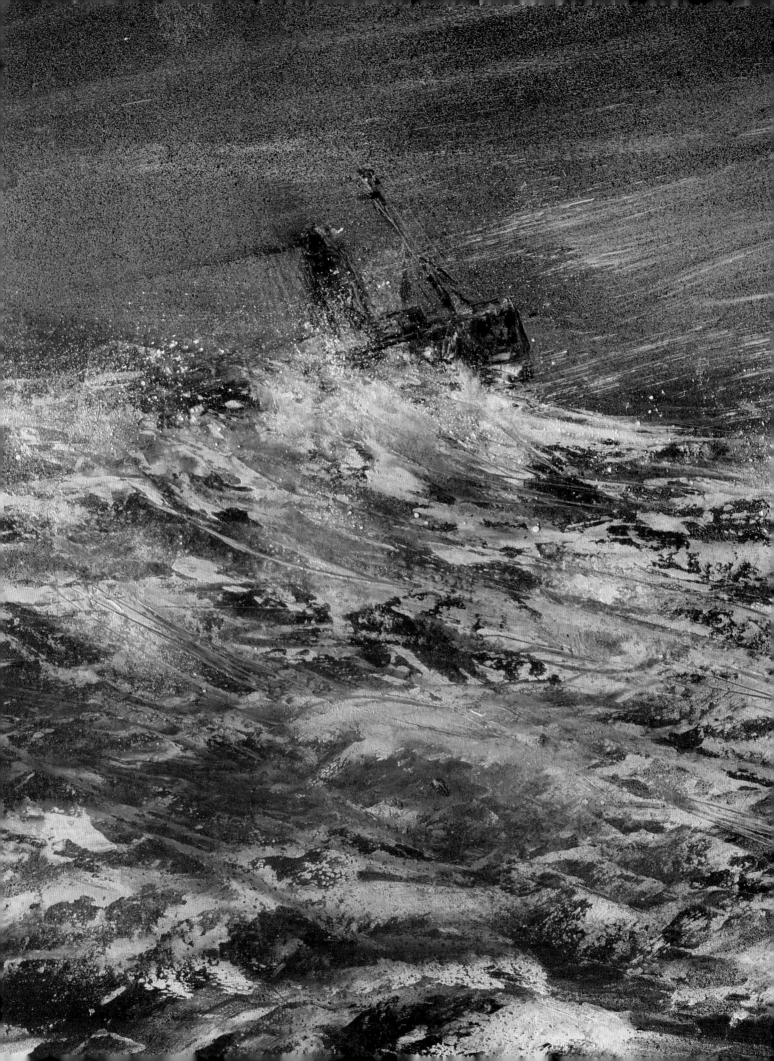

INTRODUCTION

My first reliable memory is of lying in bed and watching distant clouds silently sliding toward a group of winter trees and wondering if they would tangle in the spiky branches as they went over. I must have been about four, and I have watched them ever since.

My family say that I drive like a 'senior citizen'; I am, but the real reason I drive slowly is that I can keep an eye on the sky ahead without endangering passengers or others. On a liner going into a force nine gale I was politely asked by a member of the crew to come inside from where I had been hanging on at the prow.

A little studio I once had was at the top of a hill looking directly into the West. Many evenings we would down tools and take our chairs for the 'Ever-Different Sunset Show'. Whistling and clapping following the last sliver of sunlight.

It is not only the visually spectacular skies that enthral me, but the knowledge that they are quite indifferent to us, having monumental business of their own elsewhere. I have never failed to be amazed at the ever-changing, never-repeating, endless moods of weather.

There are also endlessly different approaches in trying to capture the energy and drama of the sky and the sea. The following pages are not written to persuade that one way is better than another: my job, as I see it, is to lay out clearly and concisely the techniques and methods I have devised or come across, and this I do gladly.

As I cannot know where the reader is in his or her experience as a painter I can only detail my method and approach, and let the reader use them as possible stepping stones. Whether you choose to follow my directions step by step or not is your choice, but you must always be very aware of what is happening in your own painting.

Perhaps the most difficult thing to look at is the idea that painting and drawing are like other skills that can be learned, step by step, from an experienced practitioner. I do not believe that they can. In painting, it is only ourselves who can attempt to orchestrate our own development. Who would want it any other way?

Learning to paint is rather like learning to sing. A good teacher will help us find our own voice. To imitate another because we wanted to be able to sing like them would surely be quite painful. Sooner or later it would become apparent that this is what we had been doing, and we would arrive at a cul-de-sac.

A seasoned teacher, I have seen that people learn best from observing in action someone whom they respect, and that their own interest in what is happening will select and retain the information that will be the most useful to them. This is preferable to following prescribed guidelines.

I have taught in the Near and Far East, where European painting and drawing have had a huge influence: this has led to much copying and imitating as a way of learning. Many artists there have become very good at such imitation – and it has no doubt helped them to earn a living – but it poses the question 'Where do you go from here?'

Looking and listening to others lets you see how another person has set about relaying images that have meant a great deal to them.

So, not a bad starting point would be to put on hold everything with which we may have forearmed ourselves in the way of dos and don'ts and start with a relatively clean slate. Just trust that anything that we need to know we will recognize when we come across it.

Peter Rush.

Featured Artists

When I was first asked by Crowood to write a book on painting seas and skies I was delighted, of course. There wouldn't be a problem. How could there be? Hadn't I been an artist for sixty years, man and boy? I must have learned something in all that time that would be worth passing on. But, and not for the first time, I was pulled up short after walking straight into great pockets of ignorance when it came to writing about mediums that I thought I was familiar with but hadn't actually used that much.

Pen and ink drawing and working with coloured inks I was happy about, as I had used them in my forty years as an illustrator; and oil painting I had always done. It was in trying to tackle pastels, watercolour and acrylics that I became unstuck. I took classes in pastel drawing in an effort to bridge the void but I couldn't escape that, much as I respected these mediums, I really didn't have the feel for them.

Rather than irritate the artists who had spent their lives working with them, I asked around, looking for accomplished artists in these mediums who also loved painting seas and skies. It is therefore with great pleasure that I am able to include the work of several other talented artists in this book.

Their sailing and walking interests must help explain why the work of these artists has such a quiet, natural authority, and I am delighted to share these pages with them.

Ros Harvey

Ros Harvey works in the north of Ireland (though not Northern Ireland). Her paintings speak for themselves but she has also written articulately about her method and approach. One of its outstanding aspects, to my mind, is its honesty.

All the seeming oddness and awkwardness of Nature and of the weather, she has recorded faithfully and unflinchingly. It is rare, in my experience, to find a painter who doesn't tidy up as they go along, trimming it here, modifying it there. Another in this mould was Joan Eardley, who worked in Glasgow and the wild east coast of Scotland.

Cathy Veale

Cathy Veale is another fine painter of seas and skies. She works in watercolour and has a unique feel for her subject matter. This has resulted in beautiful sea/sky paintings and a very open and articulate account of how she works. I know of no other painter who so uncannily captures watery transparency and the surface tension of ripples on a near-motionless sea.

Like Ros, Cathy is a sailor. That might tell us something.

Andrew Lievesley

Andrew Lievesley's use of acrylic gives his seas and skies great authenticity, and looking at his paintings you can almost feel yourself striding through his landscapes. He is a great walker himself and a fine photographer, to whom I owe most of the photographs in this book.

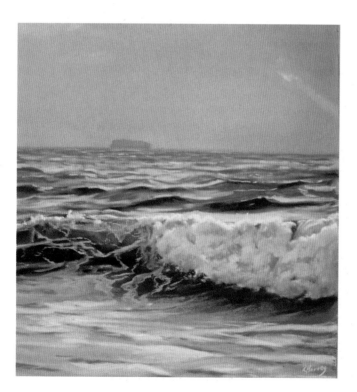

Ros Harvey, **'Wild Wave'**. 36 × 49cm. Pastel.
This is a choppy evening on our strand. I love the back-lighting and the hazy sun. I call it wild because it was unexpected. Its relatives had just flopped and skittered in with no breaking power.

Cathy Veale, **'Sail'**. Watercolour.
*Capturing a certain quality of light that defines colour and
form is important in Cathy's work.*

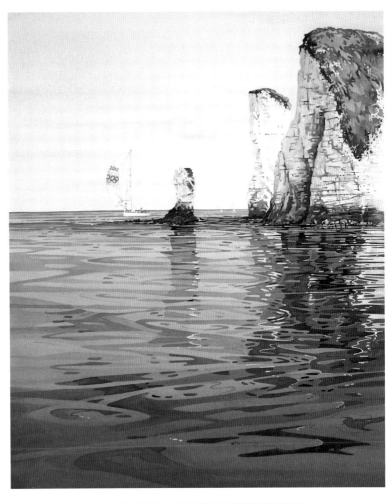

Andrew Lievesley, **'Sea 6'**. Acrylic.

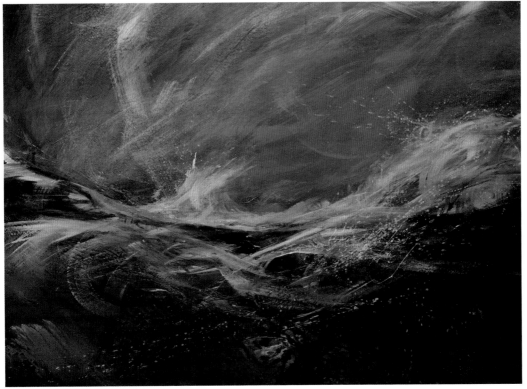

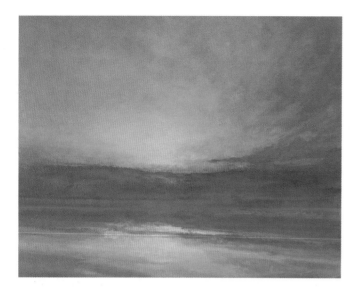

Ken Bushe, **'Sunrise from the Castle'**. 36 × 41 cm. Oil on canvas. *This was scaled up in the studio from a small outdoor oil sketch that I particularly liked. It was painted directly in fairly stiff oil paint without any drawing. After the initial painting was dry, I kept working over it with palette knife and brush, scraping bits off, leaving others and then going back again (still following the initial sketch fairly closely) until gradually the painting took shape and began to get its own identity. After this I ignored the sketch and let the painting develop in the direction it seemed to lead me!*

Ken Bushe

Ken Bushe is an example to us all in his commitment. How many of us would willingly get up while the stars were still showing and cycle off with him to paint the first light of the day? It is commitment like this that enables the experience to still be fresh when the painting is finished later on in the studio: there is no loss of integrity. His paintings have the quiet intelligence that can only come from being there.

Rachel Sargent

Rachel is a great innovator. I think it is fair to say that she will use any mediums in any combination to get the effect that she is looking for, but she doesn't let these effects carry her away. Every new medium, some never used before in painting, combining with others give birth to a whole range of new possibilities.

Jo Bemis

Jo is one of the very few painters who paint waves without their appearing fixed and suspended in time. Perhaps it is the spray being pulled off by the wind that gives that racing movement, one part of the wave drawing itself up, the other plunging headlong down.

Peter Archer

Peter Archer's wonderfully hazy and impressionistic skies are hugely atmospheric. He gives us just the barest clues to the scene and we are invited to let our imagination complete the experience. Hazy, but by no means vague, and atmospheric, but by no means dreamy, it is a very individual take on the natural world.

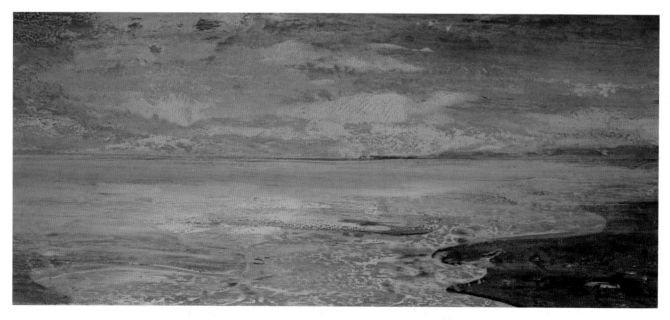

Rachel Sargent, **'Harbour'**. 40 × 25 cm. Emulsion and acrylics.

Jo Bemis, **'Storm Wave'**. 90 × 90cm.

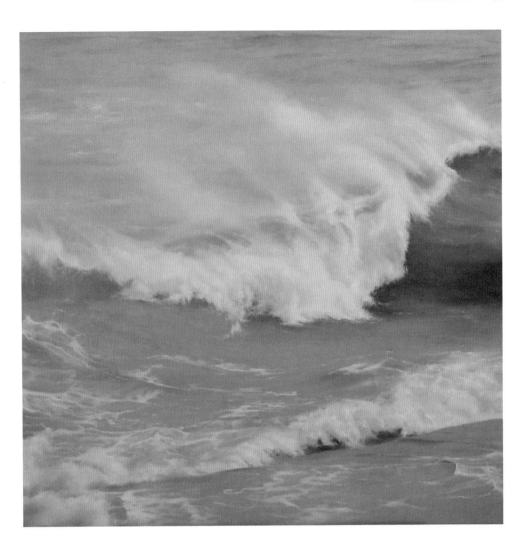

'**Harbour Lights**'. 70 × 120cm.

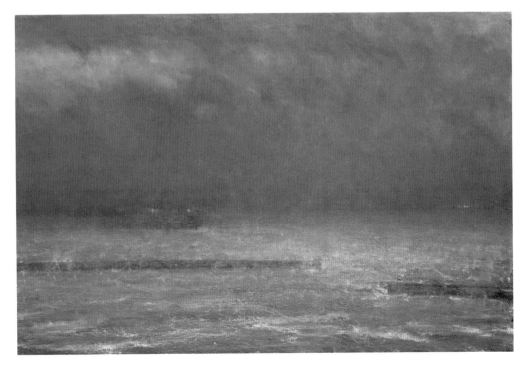

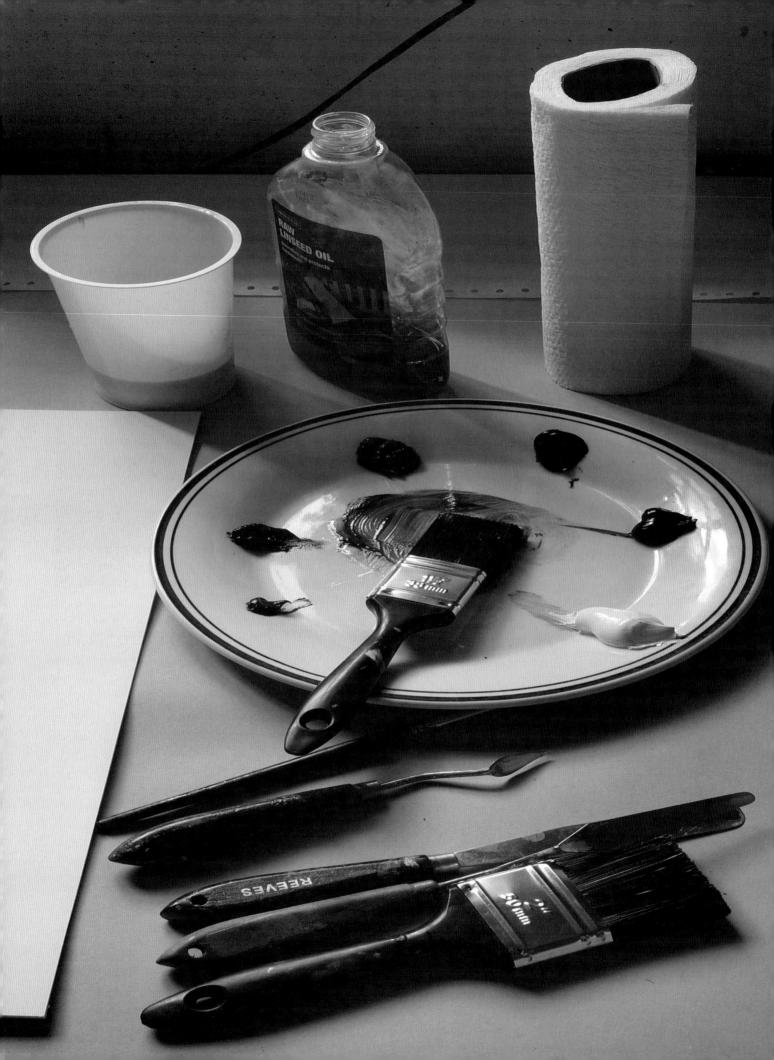

TOOLS AND MATERIALS

Painting on Boards

I use hardboard and MDF (Medium Dense Fibreboard). MDF is made of compressed wood dust, and is very rigid and very smooth. Hardboard is made up of compressed tiny bits of wood; it is rather more flexible than MDF, but it can warp. Despite this, my preference is for hardboard. The surface is flecked with minute changes of colour and tone from the tiny wood chips. The surface is more alive than the surface of MDF. If, when painting, the paint should go thin or the hardboard show through anywhere, then this will appear as neutral, not interfering with the painting but not alien to it either.

Both these boards are wonderfully inexpensive, considering what can be done with them.

What would William Turner have done if you had given him a huge sheet of MDF or hardboard? He would have looked in wonder at its smooth, unblemished surface, then given a long, low whistle of appreciation. Prior to the invention of hardboard in the 1930s, the only way an artist could get a large, smooth surface to paint on was to stretch canvas on to a frame or to paint on to a plastered wall.

Canvas

Many people enjoy using canvas as it has a marvellous way of dragging the paint off the brush. However, it is not for me. I find that because you are working with the fixed edges, the brush strokes will unconsciously begin to subtly anticipate these edges and slow down, and this shows.

If the canvas is slightly slack and you are pressing hard on it with the brush, the wooden frame of the stretcher behind it will make itself felt, resulting in more paint being pulled off the brush as it goes over. A disconcerting line has then appeared.

Also, it is not possible to change the shape of your painting or to crop it without first taking it off the stretcher. A way round this could be to pin the canvas to a board to paint on, and later to put it on to a stretcher when you have decided on its shape and size.

Priming

I use PVA for priming. It is liquid plastic and, although milky when painted on the board, is transparent when dry and gives a fast, slick surface. It is also astonishingly cheap.

If you prime your boards or canvas with white, an inexpensive and very satisfactory way to do this is to add 35 to 40 per cent PVA to white emulsion. This gives a highly glazed surface, not porous and impressively tough. Two coats will give a very smooth finish, although this might not suit those who love the rather rough, dry texture that is typical of canvas. Adding PVA to any emulsion improves the quality hugely and gives a lovely 'quality' finish.

A touch of acrylic colour plus approximately 30 per cent water can be added to the PVA. By doing this we get an overall background tone to the painting – at certain times of the year there seems to be a rose madder tinge everywhere, particularly in mid and light grey skies.

I often add dark turquoise to the PVA when I know that I am going to paint the sea. Sometimes I paint different parts of the board in a slightly different tone. Many people prime their boards or canvas with white, but it seems to me that if you do this it would be impossible to get an overall sense of the painting until every bit of white had been painstakingly painted out. Tiny flecks of the white may still show through even then. If the priming has been done with a helpful, neutral tinge then you are able to paint darker where you need to and lighter where you need to, as you go along. It lets you paint more immediately and if something has worked first time (with luck) then you can leave it. Knowing when to stop, to leave it alone, is a lesson that I am still painfully learning.

The boards are sawn to a rough size by hand and the PVA painted on with a cheap, stiffish brush: about three coats, drying

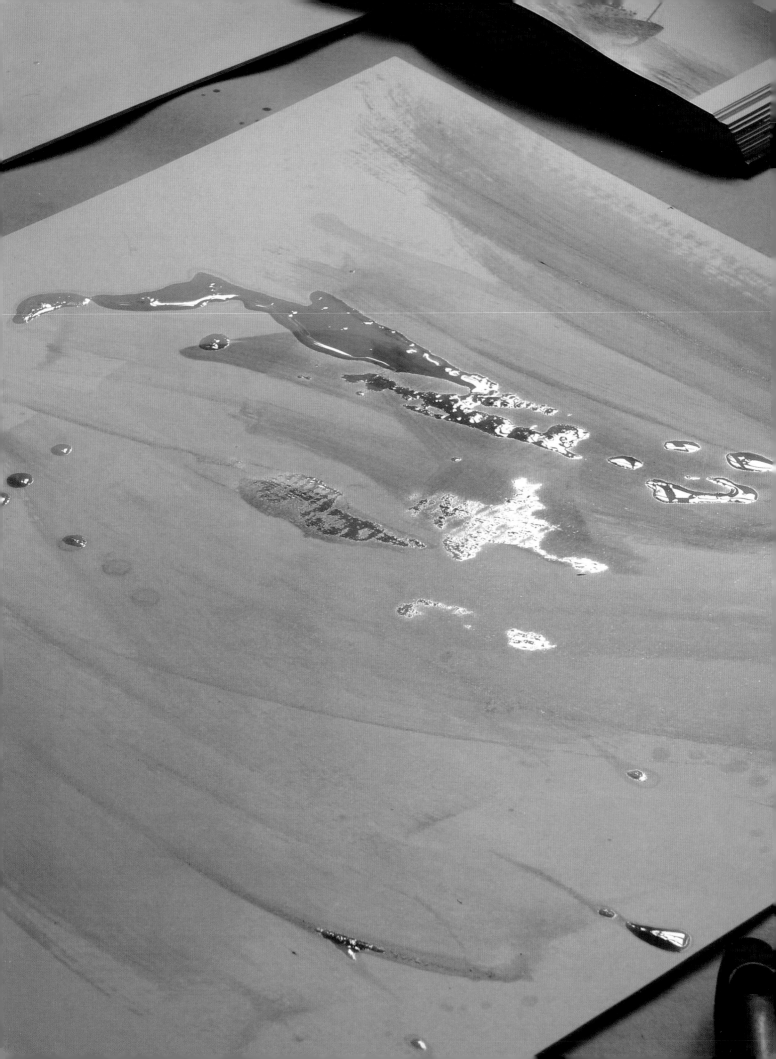

between each. The reason for the coarse brush is that it will leave tiny streaks and ridges. If you criss-cross these brush strokes with each coat you will create a 'canvas effect', which is useful and pleasing.

I tend to tack the boards to a wall to paint to stop any irritating movement or springing, which can happen when using an easel. The downside of doing this is that the light and its reflections are fixed, making some parts of the painting more difficult to see than others. To counter this I take it off the wall often and look at it in another room, where it can look very different.

Tools

I use a great many tools in my painting. What they have in common is the ability to give the 'untouched-by-hand' look.

When I first started painting the result was a plethora of wild, criss-crossed brushstrokes. I took pride in them, even; that was my style. Since then I have come full circle. I feel now that heavy brushstrokes give the game away. I prefer now to have none of them showing up at all, as it shows to the viewer how the painting was put together. If the painting does have this 'untouched-by-hand look' the viewer is left with just the immediacy of the picture itself and is not caught up in the side issues of becoming aware of construction.

Palette Knife

This is marvellous for dragging and smearing paint, for cutting through and for drawing short, straight lines.

Cooking Spatulas

Similar to palette knives, but carrying more paint, spatulas are good for spreading and flattening paint.

Bricklayers' and Plasterers' Trowels

Trowels are used in the first stages of the painting to spread great swathes of paint. They are usually limited to a few, simple passes.

Window Cleaning Squeegee

Squeegees are useful for smearing large, thin layers of paint, but they tend to leave a line of thicker paint at the end of the stroke: this is difficult to erase without spoiling the effect that it has just created.

Wire Brush

Perfect sometimes for pulling through semi-dry paint and giving the impression of long grass or reeds bending in the wind, wire brushes are useful but hardly ever used.

Dentist's Tool

This is very useful for detailing, or cutting out hardened knobs of paint. I use it for signing paintings, scoring my surname in the wet paint.

Spray Diffuser

Spray diffusers can be used for blowing neat turpentine on to areas of wet painting, causing it to soften and slightly diffuse – it dissolves hard edges of any wet paint, often fatal if overdone (fatal to the painting, that is). A diffuser can easily be attached to a small compressor, saving you from having to blow, and the painting needs to be flat if you don't want to have to deal with any dribbles. The diffuser needs to have a thin wire kept down the thinner tube to keep it free from blocking, so that it can be used immediately and not cause you to be distracted.

Linseed Oil, Boiled and Raw

Raw linseed is slightly green, boiled linseed is warmer, but refined linseed oil is best, being clear, but it is expensive. Linseed is not often used on its own as it is very oily and thick, making paint slimy, but this may be just what you want. It takes time to dry and can also be more useful when a little turpentine or white spirit is added.

Turpentine and White Spirit

Pure turpentine, distilled from pine resin, is lovely: it has a sharp, tangy odour that makes the studio feel like home. However, it does not behave very differently from white spirit, which is distilled from coal and is cheaper.

Rags

You will need lots of these!

Toothbrush

These are very occasionally used for splattering by running your thumb across the paint-loaded bristles.

Brushes

I use artificial brushes – artificial inasmuch as they have nylon bristles. They survive the oil painting and cleaning process better than hog's hair bristle or sable, and they also retain their spring and their points better.

Flat Watercolour Brushes

These wide, flat watercolour brushes are the most pleasing of all to use with oil colour. The widest I have come across are 7 cm wide and are flat-ended. The bristles are nylon, soft and springy, and apply the paint lightly and delicately; the brush leaves hardly a mark or trace of itself at the end of the stroke. Marvellous for blending one colour with another and especially for lightly sliding over the thick, wide paint often used in painting clouds, giving the impression of the clouds being moved along by the wind and spreading out.

Being more delicate than oil painting brushes, they have to be very carefully cleaned.

Household/Painters' Brushes, Small and Large

These need to be very clean and soft.

Masking Tape: Wide and Medium

Vital for cropping paintings little by little until the painting feels balanced. Sometimes, if I find that I have lost the big picture – usually by overworking, by making too many small changes or, more likely, by trying to be too clever – there may be a small part of the painting that *does* work and is still fresh. This can be isolated by framing with masking tape to see if that little picture can stand on its own.

Small Sponge Roller

A roller is mechanically repetitious in its application of paint so, unless perfectly applied, it leaves repeating marks as it goes along. When I use a roller, which is not often, I fix it so that it can no longer roll and then use it to drag and smear paint. Even so, it will leave a hard edge.

Gaffer Tape

Excellent for sticking up the board onto the wall. Marvellous stuff, anyway!

Spray Cans

The delicate, light, open spray, which settles and does not run, can make so much difference to bringing a painting together or changing its mood. When sprayed onto thick wet paint it can be gently cut into with a palette knife revealing the colour underneath. As far as I know, spraying from a can has no long-term detrimental effect on the painting.

Wide Brushes

Varnish brushes are usually quite stiff, but tend to leave lines and streaks when used in the painting.

Cling Film

I wrap several layers tightly round a spare piece of board to act as a palette. Cling film is not a particularly pleasant surface to mix up on but it works. What is pleasant is just peeling it all off, paint and all, and throwing the lot in the bin at the end of the session.

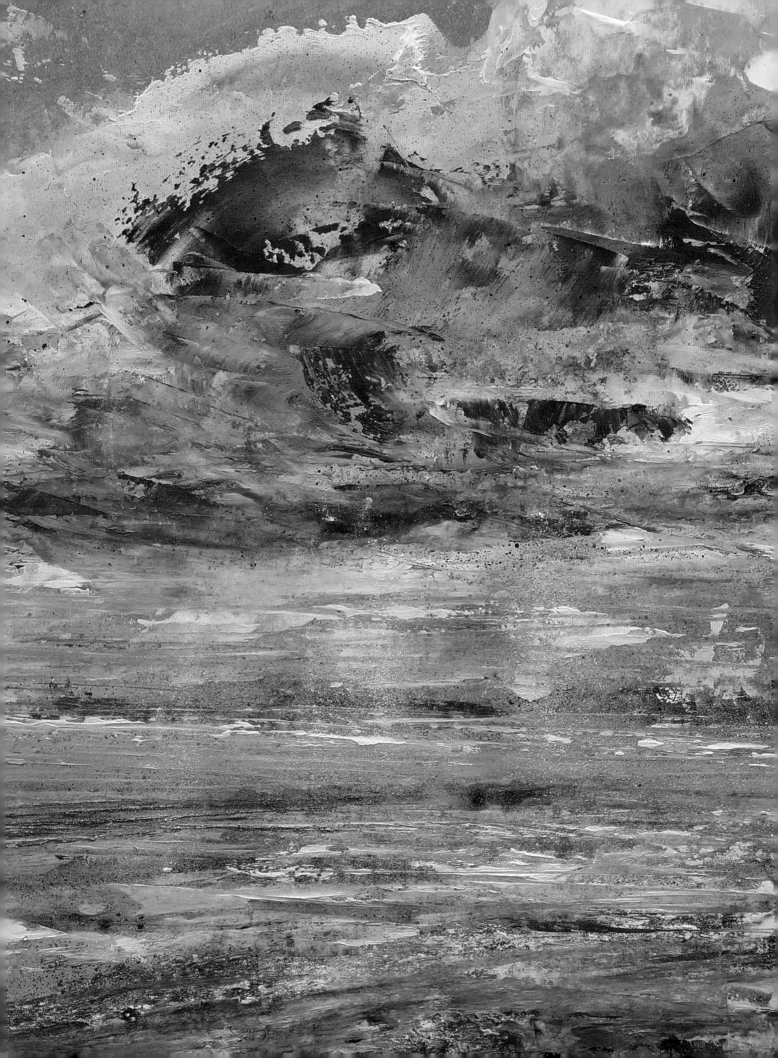

TECHNIQUES

There are, to my mind, no rules in painting. No 'dos' or 'don'ts' to shelter behind. We are unnervingly free. (Having said that, there is one obvious rule, that paint should not be able to crack horribly and fall off the board or canvas at a later date, when it may belong to somebody else. Nor should it be able to lose its vibrancy through poor priming.)

Painting Outside

There is nothing like painting outside. You can get away with nothing. You look at the scene that you are painting, move your head slightly, and there is your interpretation of it. When these two are seen together the difference can be quite thought provoking.

Don't give up.

For painting outside there are many different ingenious easels for standing and sitting at. I recommend any that are not too complicated or too flimsy, easels that you don't end up having to hold with one hand. I sling the board between two big wooden easels and have guy ropes and clamps in case the wind catches this board. A sturdy, small portable workbench is needed to clamp the palate on.

I have come to appreciate the little folding 'work mates' that are made for carpenters and plumbers working on-site. Too heavy to carry far, but small enough to fit into the boot of a car, they really are sturdy and versatile and you can adapt them for pen and inks or watercolour where the board needs to be secure, stable and flat, as shown in the illustration.

One of the hazards of painting out of doors is that tiny flies kamikaze into the wet paint, into your lovely fresh skies. Either they remain there to look like little Tiger Moth aeroplanes coming over the horizon, or you can scoop them out with your finger and leave your sky like a ploughed field. Rain doesn't help, either. I am lucky to have a little camper van – I can keep dry, make tea and stay there all day, doing several paintings of the same scene in different lights.

(Passers by, too, can be very irritating. Somebody once stood behind me while I was painting, then stepped forward and inspected it, hands on hips. After a good full minute he turned and said 'Well, I suppose it keeps you out of mischief.')

Alkyd paints, which are similar to oils, have the advantage for the out-of-doors artist of being quick-drying, being touch dry after about six hours. This means that if you are painting outside for the day they are much less vulnerable to damage on the journey home. They will mix with oil paint, and come in an opaque and a translucent form.

A carpenter's portable 'work mate' adapted for use as an outdoor easel.

KEN BUSHE

I live and work every day beside water. The view from my window is just the River Tay – a mile wide at this point – and all the sky above it. In rough weather, salt spray strikes the glass.

I'm painting the dawn this morning. I get up at least an hour before sunrise and go outside to check the amount of cloud in the sky. If it's totally cloudless or completely overcast, I'll go back to bed! It looks good this morning, though, with faint patches of clear sky and stars showing between the cloud.

Time to check over my painting gear. Everything I use is packed into a large rucksack, which should be ready to go, but I always double-check every item. Oil paint, palette, brushes, palette knife, turpentine, canvasses, kitchen roll, sketchbook and pencils, camera, spacers to carry wet canvasses back-to-back, something to sit on, and binoculars if it's summer when there could be dolphins around.

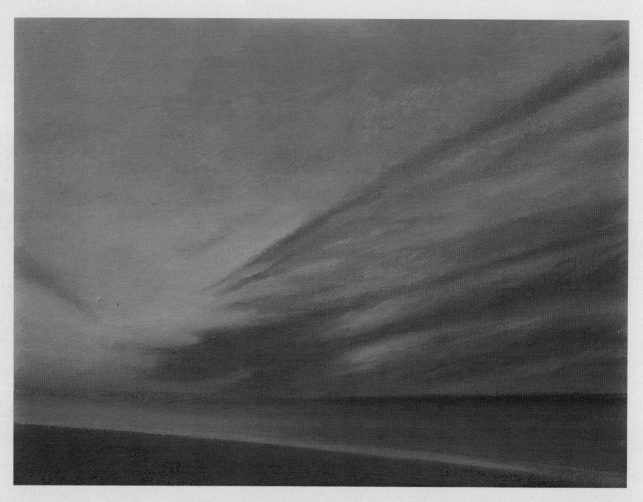

Ken Bushe, **'Cloud Study, 8 October'**. 15 × 20cm. Oil on canvas.

This was painted outdoors from a spot overlooking the North Sea during a spectacular sunrise. It was painted directly in oil to lay out the main elements, tones and colours without any preliminary pencil drawing. I allowed it to dry, and then further developed in the studio to build up layers of colour within the painting and refine the image.

It's all there. I wait until the first glimmer of light is showing and set off. There's a really good spot to paint the dawn about a mile away from where I live, so I cycle there. It's on a raised grassy bank with a cycle path below, and it has an uninterrupted view across the North Sea. I wheel the bike up the bank and unpack. Being higher up on this bank means that few people can be bothered to walk up to see what I'm painting, which can be distracting. There's a much better view of the sea from here, too.

I don't use an easel for small canvasses: I paint sitting down so the palette and everything else can just lie on the grass beside me. I made a palette with a lid, which lets me bring all the colours home intact without first having to wipe it clean and I

clip a length of kitchen roll to the (separate) palette lid to stop it blowing around in the wind. I clean my brushes on this; the palette itself and its paint sits right beside me. The brushes are stuck handle-down into the grass, ready to grab.

When I've laid out my white, mixed up a few tints that I'm likely to need and everything else is ready to use, I begin drawing out the basic shapes that I see within the sky in a small hardback sketchbook. There's time to do this before the sunrise gets really colourful, and it very quickly stops me thinking about anything other than what's in front of me ... a starter before the main course, if you like, to concentrate the mind.

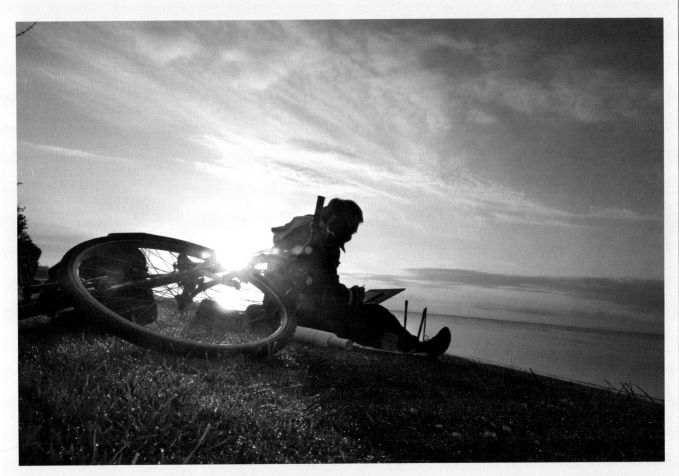

This photograph was taken while I was painting the small oil painting 'Cloud Study'. I'm sitting on an elevated bank overlooking the Tay Estuary and the North Sea, where I often paint the sea. For a large part of the year here, the sun rises directly out of the sea, often in a magnificent blaze of colours and cloud shapes. One has to paint quickly, concentrating on only the major elements of the painting before the sky 'moves on' too much. Detail would be a hindrance when painting in this way.

KEN BUSHE (Continued)

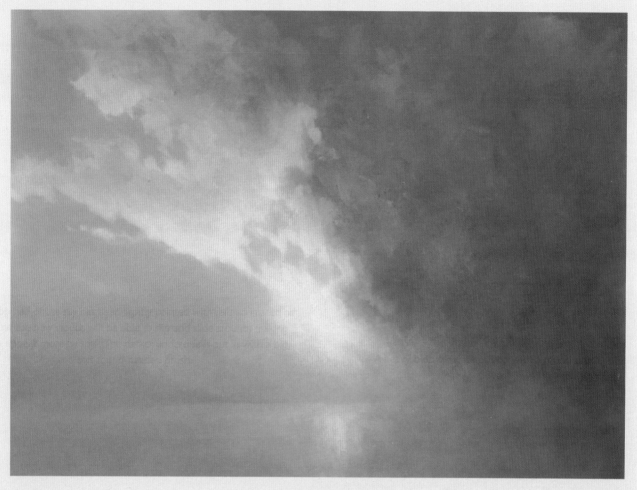

Ken Bushe, 'Sunrise Through Mist'. 45 × 60cm. Oil on canvas.

The sun has just risen above a low bank of light mist, and this painting is an attempt to capture the brilliance of those first moments of direct sunlight over the sea. I began it outdoors as a small oil sketch with supporting photographs and later scaled it up in the studio: small outdoor oil paintings often have a raw energy that can translate well into a larger-sized canvas. It is painted 'from the highlights outwards', taking care to build up layers of brilliant white oil paint and thinly glazed oil colour around the sun, gradually reducing the colours and tones as the eye moves outwards and away from this.

I paint directly on the canvas with no preliminary drawing, but still taking care to get the first few brush marks in the 'right' place. From now on, speed is everything. The sky is changing by the minute and the painting must follow it.

I build up the main elements in the sea and sky as quickly as possible using tone and colour but very little modelling or detail. There's no possibility of glazing or much layering of the paint at this stage and it's best not to overwork a small canvas anyway. I'm aiming to keep it as fresh and alive as possible. Bits of blank canvas left bare are fine. I've no intention of painting a 'finished' work outdoors, just the major shapes, colours and tones and, above all, the composition.

I like to bring all the raw, rough-edged energy of an outdoor oil study into the studio. Sometimes I'll go indoors and work straight away on it while the actual scene is still fresh in my mind. Sometimes I'll let it dry and paint in a more considered way later on. An oil sketch like this will take quite a few sessions to complete; usually this is stretched out over a week or more. The important thing for me is to combine outdoor and indoor painting on the one canvas. Whatever the original sketch is like, painting outdoors always leaves an indelible impression in my mind that I can tap into later in the studio. The sketches can be scaled up later and turned into large paintings with all the advantages of having a strong visual memory of the actual scene in mind.

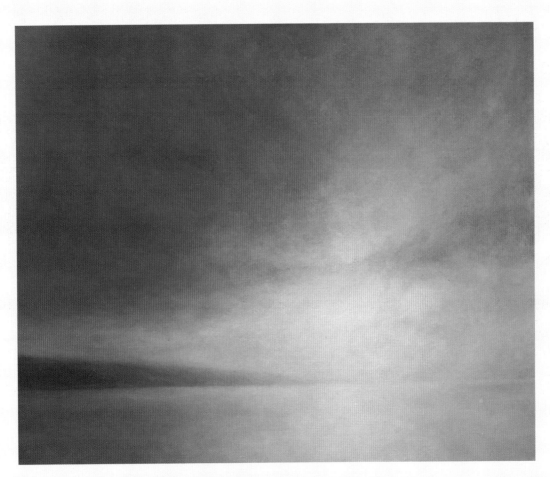

Ken Bushe, '**Sunset from Fisher Street**'. 45 × 60cm. Oil on canvas.
This is the view of the sky and the River Tay that I see every day from my window, and I've titled the work with this in mind as a salute to and as thanks for what might be seen out of a good window on a good day. The sky to me is a living entity and, as such, it has the potential to surprise us every now and then. Compulsive observers of the sky will know that events often surpass our conception of what is possible.

Photographs

I keep and take many photographs of the skies and sea, and never miss an opportunity to buy books or postcards that will show skies, seas and landscapes. Perhaps this is why I am drawn to estuaries, where there are all three.

Photographs make useful starting points for paintings done in the studio, but the photographs themselves are not always truthful and, as the painting begins to take over, they are no longer referred to. Quite often I use the weather outside the studio as a possible starting point. My paintings generally follow the seasons: in the summer for the sunlight hitting the earth's surface and bouncing; the winter is more moody, atmospheric, sometimes deadly still, sometimes wild.

So, the conclusion is that photographs are useful but that the painting suffers if it has been forced to replicate the photograph. It is strange how easy it is to recognize in a painting where this has happened.

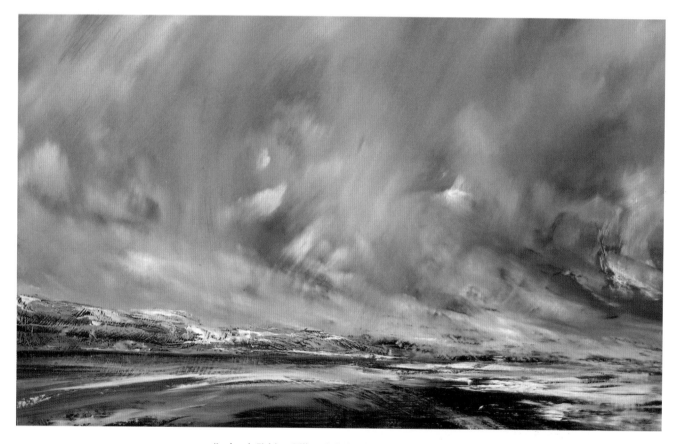

'Iceland. Fishing Village'. 149 × 120cm. Oil on board.
This painting was started outside in the bitter cold, but quite soon a fine mist made the paint slippery. It was finished in the studio.

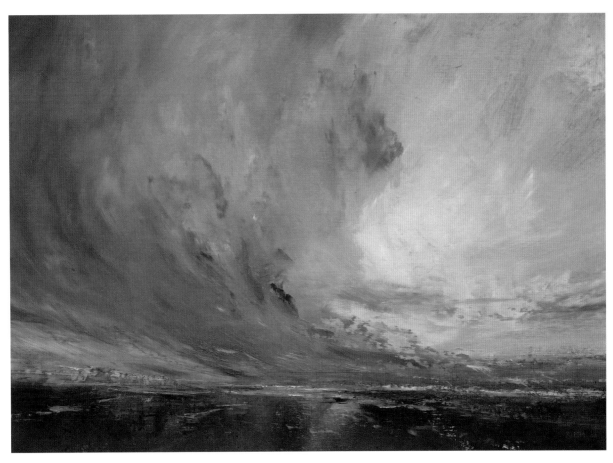

'Beach. Romney Marsh, Sussex'. 85 × 125cm. Oil on board.
Painted outside just after heavy rain. The sand was quite soggy and the easel kept tilting. Finished in the studio.

Composing a Landscape with Clouds

The first attempt
The first original sketch of a Border farm seen from the road. The sea could just be glimpsed through the trees. The foreground fence helped the feeling of distance to the farm. The furrows of the ploughed field also help in this, but by pulling the eye needlessly to the far left seemed to unbalance the picture.

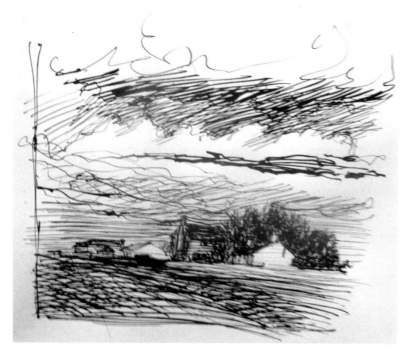

The second attempt

Pulling the buildings across seemed the most obvious thing to do and losing the fence in the foreground made it less cluttered, but still the eye was swept to the left by the perspective of the furrows. Under different circumstance this could have been a useful device, but in this case was unhelpful. I had now managed to rob the picture of its 'scale,' its grandeur. The very thing that had attracted me to it in the first place.

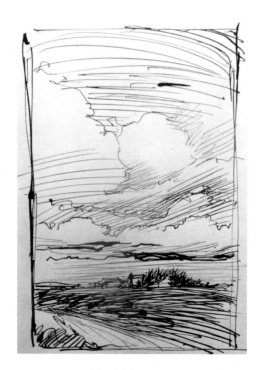

The third attempt

Going up into the clouds above and diminishing the buildings was getting me closer. By reducing the foreground field to just a dark narrow strip without much detail to lead the eye into the picture, now we just have a head-on view leading straight up into the sky. The central white cloud helps to attract the eye upwards. Now I had the 'scale' that had been missing.

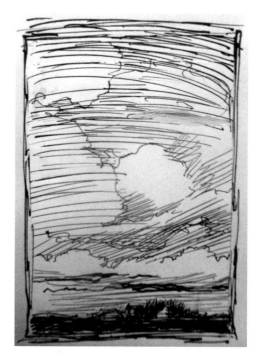

The fourth and final attempt

This seems to demonstrate the editing process that goes on. Pet ideas like the furrowed field that I had initially liked and wouldn't relinquish had hung up the development of the composition until it was reluctantly sacrificed.

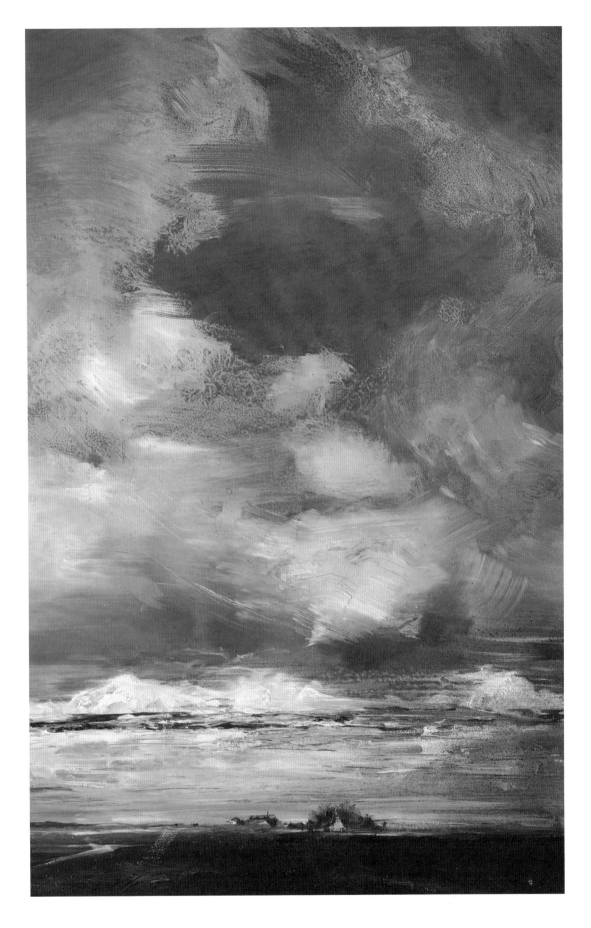

Composition

The 'Golden Section' is a way of dividing the canvas up into 'divine proportions', originating in the Renaissance. It is the division of a line into two parts whose relationship is roughly 8:13. This proportion feels comfortable and I have come to see that I have often worked along these lines without being aware of it; so too have many other painters. It may be that when we look straight ahead – as we do much of the time, thanks to evolution – we are aware rather more of the ground beneath us than of the sky overhead.

It would, however, be inhibiting to try to apply the golden section every time if the 'story' or 'overall impression' was weakened on that account. In any case, there are many other interesting approaches.

COMPOSING PICTURES, TELLING THE STORY – USEFUL TIPS

- Establish a centre of interest: what is it that you want the viewer to see most?
- The centre of interest should be slightly off-centre.
- Establish a vanishing point to give depth to the painting.
- Bright colours draw and focus attention.
- Warm colours tend to bring the image forward and cool colours make it recede.
- Colours grey with distance and atmosphere.
- Establish lead-ins at the edge of the painting; rocks and foam pattern can be useful here.
- Extreme localized detail draws attention.
- Blur sundry areas.
- The direction of brushstrokes can be used to direct the eye toward the focal point.

Some examples of the Golden Section.

Perspective

The strangest thing about perspective is that it is a completely artificial device, yet one so overwhelming that for us to see the world in any other way would appear to our minds as madness. How is it that we can see a grand country house at the end of an avenue as the size of a sugar lump, or an ocean liner on the horizon no bigger than the question mark at the end of this sentence?

There is another strange thing about perspective and that is we happily accept the pragmatic intelligence of the laws of perspective that have made our interaction with the world possible. How come a camera also sees the world in this same way that humans do?

Perspective isn't just at work in straight lines – where it is most obvious – but is working everywhere and through everything. It radiates from our eyes and it is our position in space that will determine exactly how perspective will present the world to us. It is the tiny space between our two eyes that gives us these two small different perspectives that has been exploited to make, for example, three-dimensional films.

In Western art there are two major types of perspective: arial and linear. Linear perspective suggests distance and depth through the form, the size and the distance of objects. It creates the impression that parallel lines seemingly converge where they move toward a point on the horizon, the so-called 'vanishing point'. It creates the illusion of space and depth by making objects appear smaller and closer together.

Arial perspective, on the other hand, achieves a sense of depth by making colours and tones lighter in the distance, making objects hazier and less defined. In arial perspective the linear perspective is sensed, rather than seen.

These two approaches are rather like the activities of the left and right sides of the brain. The 'left' – linear perspective – is precise, measured and quantified, while the right – arial perspective – works through suggestion, intuition and, to some extent, memory.

In our sky and seascapes there aren't usually many objects that we can refer to anyway and for that reason I will not go into linear perspective in great detail. We only need to have a good working understanding of these perspective laws to be able to sense them at work, and to use them to create the space and distance that is so much part of what we are trying to achieve.

Arial Perspective

In the following four photographs there are no straight lines to help us find the vanishing point that we know must be there because the laws of perspective work everywhere. Nature doesn't have much time for straight lines! The only chance we have is to study each photograph carefully and try to get a feel for where the vanishing point (in this case, the camera's eye) is positioned. Overleaf I have indicated my own guess, though I understand that I might be wrong.

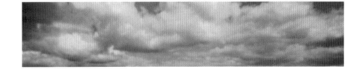

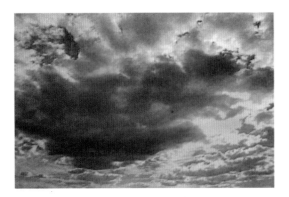

Where do you think the vanishing points in these pictures should be? See overleaf for my answers.

By curving perspective lines just as they leave the edge of the picture there is a sense that these lines are just about to go out of our vision and becoming subject to the 'fish eye' distortion that happens at the corner of our eyes anyway. It seems to help in including the viewer in the picture by making them feel that it is happening around them: this I do in my own painting. It is so slight that you would hardly notice, but it does make a difference.

I first became aware of the usefulness of doing this when illustrating for television, where the camera might start on a long track into the centre of the illustration to focus on some detail there. The slight curve in the lines enhanced the feeling of objects sliding out of vision. In painting clouds, that slight curve aids the feeling that clouds overhead are coming in from behind the viewer on either side. Distance and spaciousness can be conveyed even in paintings no larger than a postcard, so a feeling of space in a painting doesn't depend on its size.

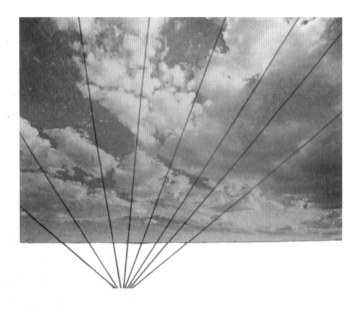

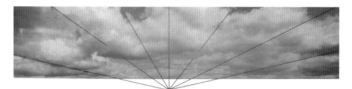

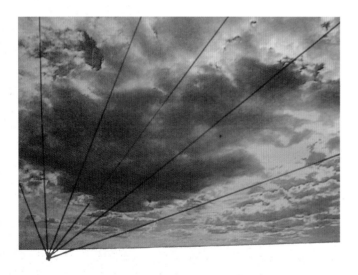

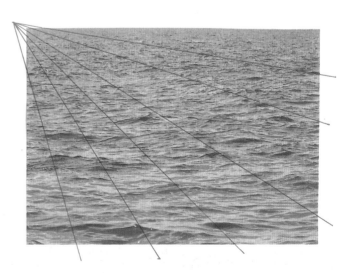

Vanishing points for all four.

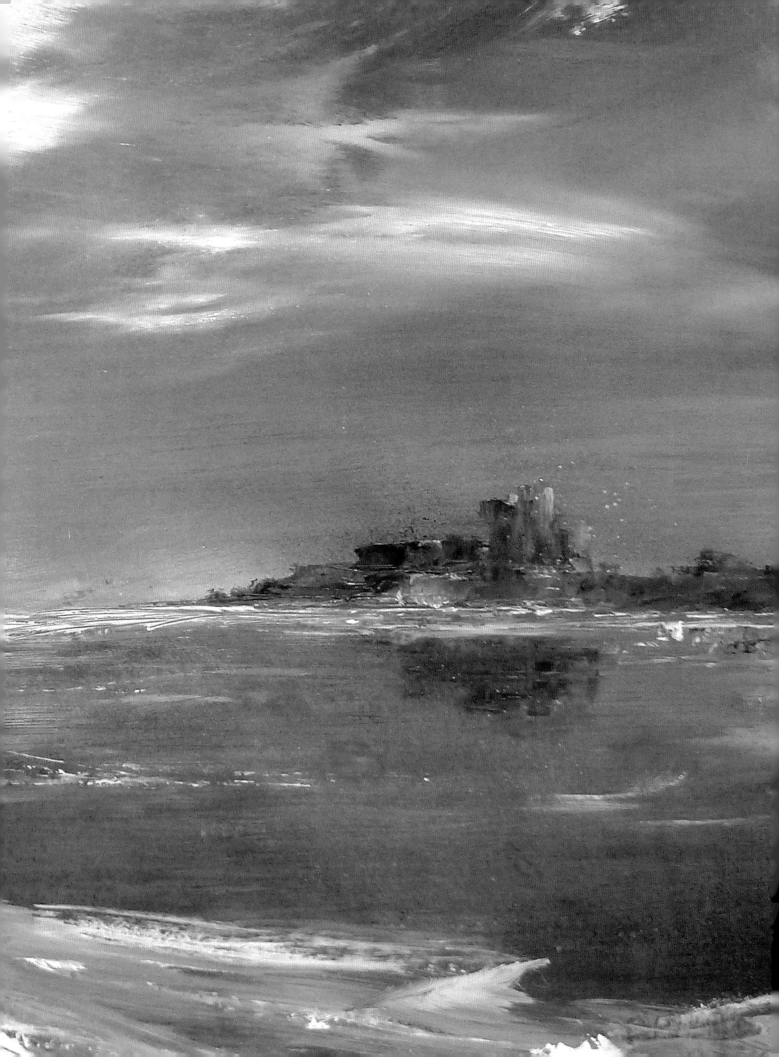

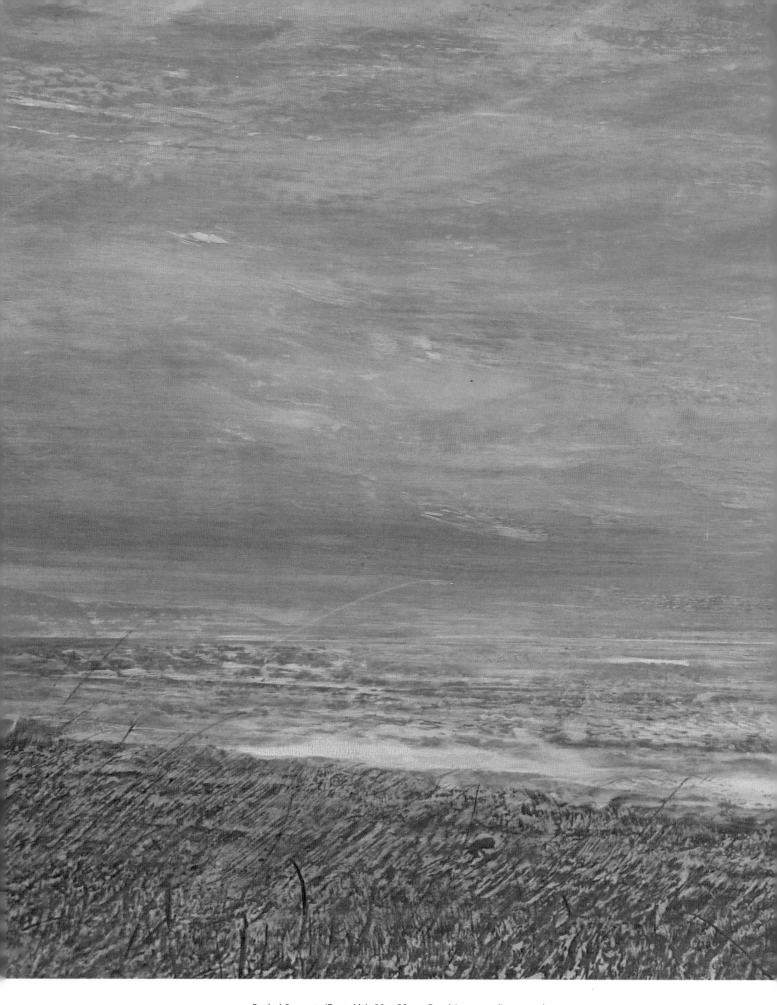

Rachel Sargent, '**Rose Lit**'. 50 × 50cm. Emulsions, acrylics, pastels.

DIFFERENT MEDIUMS

I shall begin with a brief introduction to different mediums before a more detailed examination of each.

Acrylics are available in transparent and opaque versions, and are extremely versatile. They are fast-drying, can be used straight from the tube and can be used like oils or like water-colours. Drying time can be extended by dampening the paper prior to painting.

Transparent glazes can be built up in thin layers and the glaze can be diluted with 'Flow-improver' medium. The colours remain vibrant if rainwater is used, otherwise dark colours tend to darken and light colours lighten.

Acrylic gesso is a good primer, two or three coats taking an hour each to dry. Press a loose piece of canvas into the last-drying coat and this will give a 'canvas texture' to paint on.

Watercolour is intense colour that comes in small tubes or blocks. A variety of round and flat brushes is needed to get the full range of effects possible. Watercolour tends to rely on the whiteness of the paper shining through the paint for its vibrancy, and behaves very differently according to the papers used. I have used a wide variety of mediums with watercolour to get some surprising results: sponges, alcohol, salt, dry brush, flat wash, tissue paper, plastic wrap, wax resistant, tracing paper and even a blow drier.

Tempra (also known as poster paint) is a water-based pigment with a chemical binding agent. It was first used 1,500 years ago, using egg yolk as a binder. Widely used in schools, it comes in tube or powder form and is thinned with water. It has a quick drying time and is excellent for print-making, posters and for painting papier mâché and plaster sculptures. It is applied using fingers or sponges.

Gouache is a pigment that is bound with Gum Arabic, as is watercolour, but its particles are larger than those of watercolour. It also has added chalk. It lends itself to direct painting and is appreciated by commercial artists for posters, illustrations and design work because of its opaque quality and clean edges. It translates into printing reliably.

Watercolours

Watercolour, used in the traditional way, is extremely exacting. It seems to take a certain kind of mind to use them in this way. A very clear mind: clear because, to make them work, it is necessary to know in which order to lay them down. Elsewhere in the book I have said it is similar to printing, where one colour goes down at a time. It may sound as though it is rather a rigid or dry medium, but it is anything but that.

If you look at someone who has mastered the technique you will be astonished at the verve of the brushstroke that can relay so much information so simply. Or the wash that can be so atmospheric. Or how telling the paper just left white can be. If it is used like this, not simply for colouring in drawings, then our time will have been well spent.

Watercolour paper is quite absorbent and heavily textured. The paint has the lovely dry quality of breaking up as it is pulled off the brush and runs out. This is what watercolour artists love.

CATHY VEALE

*I must down to the seas again, for the call of the
running tide; Is a wild call and a clear call that may
not be denied; And all I ask is a windy day with
the white clouds flying, And the flung spray and the
blown spume, and the sea-gulls crying.*
'Sea Fever' by John Masefield (second verse)

This is not only one of my favourite poems, but it also invokes the enigmatic mood of living on the coast that can inspire an artist, like myself, to try to capture nature's dramatic beauty.

For most of my life I have lived in the Purbeck area of Dorset and, through walking and sailing, have got to know the area extremely well. It has some of the most breathtaking scenery in Britain and is part of the World Heritage Jurassic coastline.

I have always been fascinated by water, which is why it appears in so many of my paintings. I have spent many hours studying the movement and ever-changing patterns of light created by the sky's interaction with the sea's reflections, tides and light effects of seabed formations. These factors create a wide spectrum of colour, shape and texture that I try to interpret and sometimes exaggerate in my paintings.

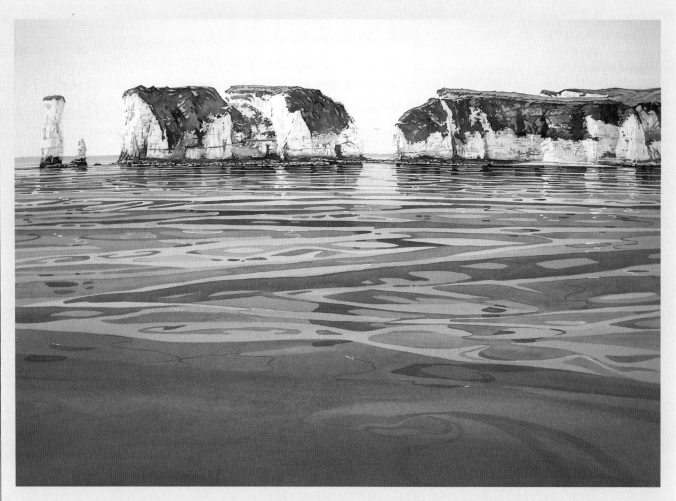

Watercolour can be applied as subtle washes to pick up the liquidity and translucency of water.

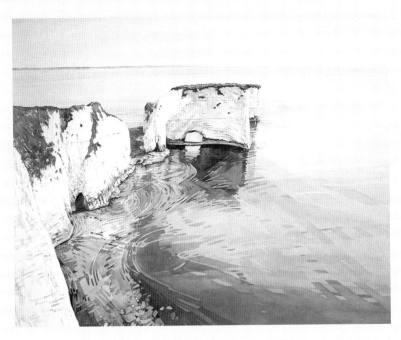

Patterns of light are created by the sky's interaction with the sea's reflections, tides and light effects of the seabed formations.

To create a convincing painting full of impact, light and atmosphere, I believe it is best to simplify what you see and try not to get bogged down with detail. The movement of water is a very challenging subject and can easily become confusing. Cloud formations from the sky completely transform the appearance of shape and colour that are reflected in the sea. For example, an approaching stormy sky with a shaft of sunlight shining through cloud can give out a deep purple-grey tinge; in contrast, where the light hits the water, a brilliant green colour. Or a still hazy sky can create a dark inky colour on the water. For me, watercolour is a wonderfully fresh medium that lends itself perfectly to painting seascapes. It can be applied as subtle washes to pick up the liquidity and translucency of water.

Beginning

Capturing a certain quality of light that defines colour and form is important in my work. I like a dramatic viewpoint and look for a point of interest that will add to the impact of the scene. Once I have soaked up the atmosphere of my intended subject, I make notes and preliminary sketches and then gather reference photographs to take back to my studio.

Photographs can be a useful tool for building an image of how a composition can take shape, as long as you only use them to select pieces of information from them and do not rely too heavily on their static image.

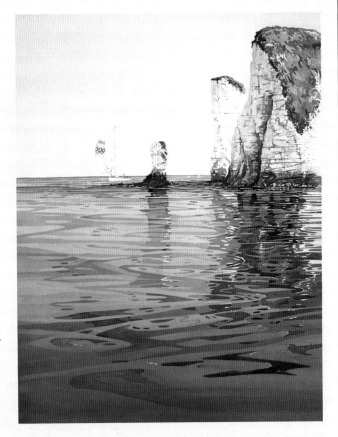

Capturing a certain quality of light that defines colour and form is important in my work.

CATHY VEALE (Continued)

Paper

Paper stretching is essential in acquiring a level surface when soaking and applying wet paint to paper, especially when using lighter papers. The water causes it to buckle and remain so when dry: this can spoil a picture and hinder its progress, and also creates havoc with horizons.

Taping wet pieces of bath-soaked paper to a board hasn't always been very successful in my experience. The best purchase that I ever made was a paper stretcher that secures the wet paper by tapping four plastic rods into grooves around the edge of a board. It produces perfect results, drying to a flat finish every time. As I generally paint large watercolours, sometimes as big as a metre in depth or height, I had to get a local carpenter to make a selection of large boards as I couldn't find any big enough. You can buy rolls of watercolour paper 1.52 × 10m. For the effect I want to achieve I use HP (hot pressed) 300gsm paper, as I like the smooth liquidity it offers.

Foundation

Having organized my reference material, I start with a simple outline of the subject – perhaps coastline or cliffs. This I draw very lightly, trying to avoid any rubbing out as this spoils the surface of the paper and consequently the purity of the subsequent colour washes. However, with care, I can erase these lines later, once the first washes have been applied. Alternatively, if I use a soft pencil, the lines will lift out when wetted. I never use masking fluid, although it can be a very useful medium for a more accurate finish.

Initially I concentrate on the foundation washes of the sky and sea areas. I do this by wetting the paper with clean water, using a large flat brush. Then, as quickly as possible to avoid streaking, I apply pre-mixed colours from my palette; I let them bleed into each other and then dry, thus creating a very soft, diffused quality. This process is repeated until I get the depth of colour that I am looking for.

I develop each painting by emphasizing form, shape and geometric angles, and by harmonizing colour. After scanning the scene and deciphering each colour I see, I then look for patterns and contrasts in tone, and without too much planning I work wet on dry, building layer upon layer of colour, allowing some of the colours underneath to show through.

It is important to keep colour washes as pure as possible, combining no more than three colours to avoid a 'muddy' look. I normally work with a fairly limited palette of richly pigmented colours like ultramarine, cobalt and greeny blues, viridian, cadmium orange, yellow ochre, raw sienna and crimson. For cliff faces I use white gouache. This helps to give substance and depth, in contrast to the translucency of the water.

I like to use flat brushes where possible, which help to create my stylized effect. Smaller rounds are used for detail such as surf or seagulls, and so on.

The next stage is an intuitive process. As I have found after years of working in watercolour, the style of my work is constantly developing. Like the sea and sky itself, it is never the same and so I let the picture evolve as I'm painting, finishing with highlights of white gouache to indicate a three-dimensional effect.

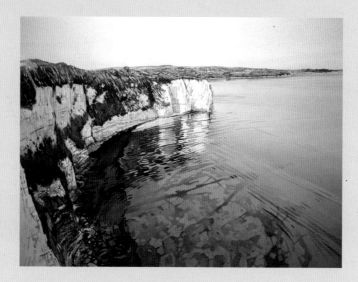

I work wet on dry, building up layers and allowing some of the colours underneath to show through.

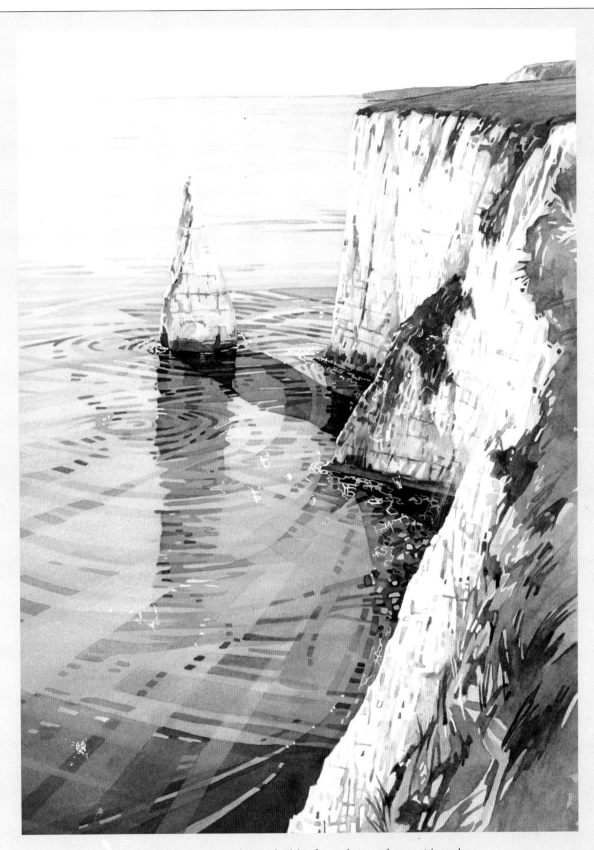

I develop each painting by emphasizing form, shape and geometric angles.

CATHY VEALE (Continued)

Consistency is the key to a successful show.

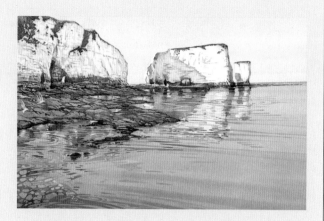

A dramatic viewpoint will add impact to the scene.

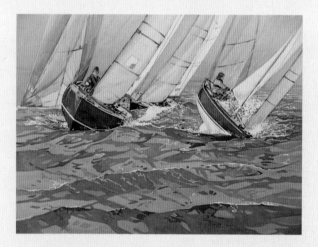

Movement of water is a very challenging subject.

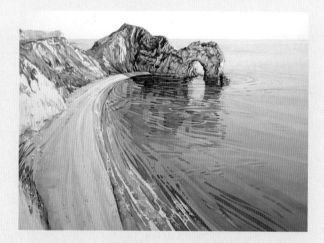

To keep colour washes as pure as possible, avoid mixing more than three colours together.

Framing

A frame can either make or break a painting, so it is important to give it some careful consideration. It is a really important part of the whole presentation of one's work, and I always go for a neutral-looking frame: bare wood with a light coat of liming wax, surrounding an antique white mount of about 60mm on each side. Dark and different coloured mounts can kill a delicate watercolour, not to mention complaints from potential buyers that the framing won't go with their decor at home. I can honestly say that by using the neutral formula I've never had any such complaints.

Exhibiting

Consistency is the key to a successful show. There is nothing worse, in my mind, than a 'mish mash' of different frames.

Again, try to have similar, neutral-looking frames or, if exhibiting with other people, make sure each individual artist's work is hung together, rather than spreading them around in different places. This will prevent anyone having to hunt around for the artist they may have an interest in. If hung on clean white screens or walls, the exhibition will look crisp and harmonious.

I always like a clutter-free exhibition, keeping cards, prints and information in one area. Too much signage and paraphernalia around screens and walls will detract from the work itself. Keep it simple: people have come to view paintings, not notices.

Pastels

Pastels, if you have never tried them, are very direct and unnervingly immediate. It is impressive how different they can be in different hands. They can range from rather light, thin marks where the background colour is ever-apparent, to rich, heavy blocks of intense colour. They are occasionally used in an airy, delicate and dreamlike way where the pastel has been rubbed and smoothed with the fingers.

This directness is very difficult to effect in any other medium; I can quite understand that, for somebody who sees and thinks like that, nothing else will do. For myself, pastels are a very valuable counterbalance to oil painting. I am obliged to forgo my usual, rather tentative approach coupled with the delicious pleasure of succulent paint, and embrace this dry, raspy pull on the pastel as colour is dragged off the stick by the rough texture of the paper.

But in exchange I have the lovely, rich, direct colours of pastel that can be blended on the paper itself with the added bonus of being free of all the preparation that goes with oil painting plus – and it is a big plus – no waste. No big blobs of expensive, unused paint on the palette that have to be discarded on account of the skin that will form on the drying paint and that will appear again as tiny specks if I am tempted to try and use it.

With pastels, if you have a good range of colours laid out before you, then you simply reach for the colour that you feel is right and apply it. With oils, of course, with a smaller range of colours the mixing is done on the palette and this can be a moment or two's distraction. This is another reason why pastels will really concentrate the mind: it is all happening so fast.

A soft putty rubber will lift off pastel without damaging the surface of the paper, but once you start working it will become grubbier and grubbier until no longer useable. Fresh bread can be kneaded into a small lump and used in the same way, with very much the same result.

Accidental smearing is an ever-present hazard. Pastel work never feels safe until a sheet of glassine or tracing paper has been laid on top and taped into place. Try to avoid slurring the protective paper, as even the tiniest sideways movement will blur the work slightly and take the edge off it.

To clean your pastel sticks, put them one at a time into a jar in which there is some rice, then gently shake.

It is easy to get quite remarkable effects with our pastels and, by the same stroke, it is probably also easy to get carried away by them. It is rather the same with coloured inks. It is disappointing just to let these two lively mediums take us over, like two wild ponies.

ROS HARVEY

When I was asked by Peter Rush if I would be interested in collaborating in this book with a section on pastels, the title *Painting Skies and Seascapes* filled me with great excitement. It is my passion.

Living where I do at the most northerly tip of Ireland, surrounded by ever-changing tides and storms that bring to my doorstep such a multitude of images, I feel that one lifetime is far too short to hope to cover all I wish to paint and express.

I will not be writing a 'How-to-do' section or cover different techniques, as there are variations on this matter that have been dealt with extensively in many books. Hopefully I can convey the love of the soft pastel medium, and how I approach and carry through the stages from roughing out to the final finish.

Pastels

I have used several of the main types of pastels available, but have always steered back to the soft. Having made ceramics for many years, I find that the tactile qualities of the soft pastel appeal to me. I like the hands-on approach and the feeling that you are almost modelling the chalk in three dimensions.

Soft pastels come in three grades – hard, medium and soft. Even these grades grade further into specialized grades, so soft can come in up to three different 'softs'! Some are so soft that they just crumble, so do be careful. Don't do what I did and spend an enormous sum on a very special 'soft' – red – to find it disappeared in my fingers. Conversely, some 'hard' pastels are so hard you need sandpaper to get any impression. The manufacturers are usually consistent:

- Rembrandt, Conte and NuPastels are 'hard'.
- Windsor & Newton and Unison are 'medium'.
- Rowney, Sennelier and Charbonelle are 'soft'.
- Schmincke and PanPastel are 'ultra soft'.

The PanPastel was introduced to me by a pastellist in New Zealand, though it actually comes from the USA. The pastel itself is ultra fine powder and if you unscrew the base of the pot separately, there are little soft chamois booties that you can fit on to sticks or small palette knives; you apply it to the surface of the paper with these. The range of colours is large and mixing together is simple, but the colour pots do have to be kept separate, and the booties clean. The term 'painting' definitely applies to this technique.

NuPastels are hard sticks, also made in the USA. They are popular because they hold together firmly and are dustless – but hard. I use hard pastels for dark undertones, and work up to the soft on the final layer.

My favourite pastels are Unison, which are hand-made in Northumberland, and Windsor & Newton. Unison are no-nonsense about naming their colours, and go for tonal ranges of each colour. They also make their sticks in two sizes: the large one fits the hand nicely, and the smaller one is a neater, rounder shape that does not snap off like the usual pencil-shaped ones. Windsor & Newton use the older names like Davy's Grey, Paynes Grey and the Windsor Blues, Greens and so on. They are very direct and smooth to use.

Oil pastels are relatively new to the pastel scene. In 1949 Henri Sennelier, Henri Goetz and Pablo Picasso got together to develop a new medium that would be between chalk and wax.

Sennelier now have a range of forty-eight permanent and non-toxic colours, and a beautiful range of metallic and iridescent colours that are a pleasure to use. They are soft and buttery, so the term 'oil' is misleading.

Holbein is a Japanese make of oil pastel. They have a range of forty-five hues, and each hue is graduated into tints. They are square sticks and easy to find in most art shops.

CRAY-PAS is probably the best known and used range of oil pastel sticks around, and are also made in Japan. I'm sure that nearly everyone including children has used a set at some time.

One of the differences between oil and chalk pastels is in the way they are blended: with oil pastels you can use oils and mediums to liquefy and spread the pastels on the support. With the waxy finish a lot of strokes and cross-hatching is also employed to achieve depth of tones and unusual colour effects.

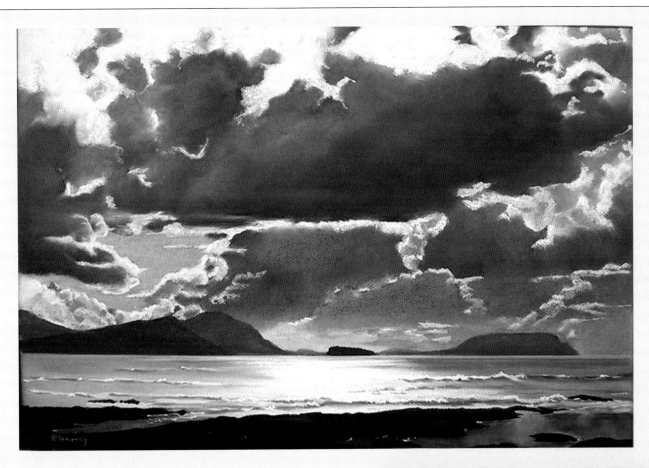

Ros Harvey, '**Midday**'. 71 × 48cm. Pastel.
This wonderful light was at midday in early spring. It had been a gloomy morning and I had not thought it would turn out so brightly. I had been to this particular rocky coastline many times, as I had decided this spot would make the setting for a cover painting on a book I had been commissioned to do. It was an extremely tricky piece of sky to paint and I thought I had lost it several times. I was using a thin Canson paper, knubbly side out, which did not like to take many layers.

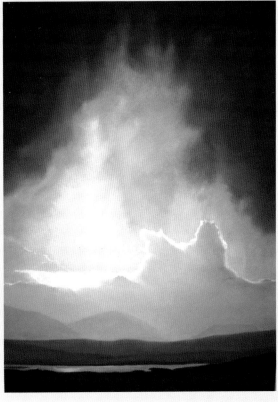

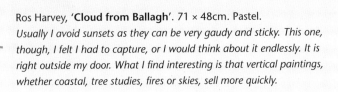

Ros Harvey, '**Cloud from Ballagh**'. 71 × 48cm. Pastel.
Usually I avoid sunsets as they can be very gaudy and sticky. This one, though, I felt I had to capture, or I would think about it endlessly. It is right outside my door. What I find interesting is that vertical paintings, whether coastal, tree studies, fires or skies, sell more quickly.

ROS HARVEY (Continued)

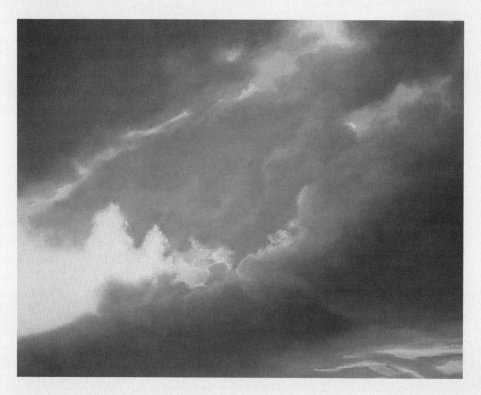

Ros Harvey, **'Indigo Sky'**. 49 × 36cm. Pastel.
This is a quieter sky. I loved the greens that shimmered around the whites. I use this as my screen saver, and it is very soothing under the myriad of folder icons and documents.

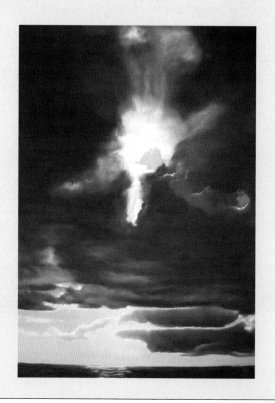

Ros Harvey, **'Break in the Cloud'**. 71 × 48cm. Pastel.
Another vertical sky. There is a fault that runs through our range of mountains, which lines up with the Scottish fault line of Loch Ness. It plays a constant part in the clouds when the sun is above it. From September to January it is more or less above our area in the late afternoon. This makes a break in the clouds, as I have shown in the painting. This happens over and over again, and changes colours and attitudes according to the weather that day. Later in the year, when the sun sets further round the mountain, the break appears earlier in the day, higher and not as spectacular.

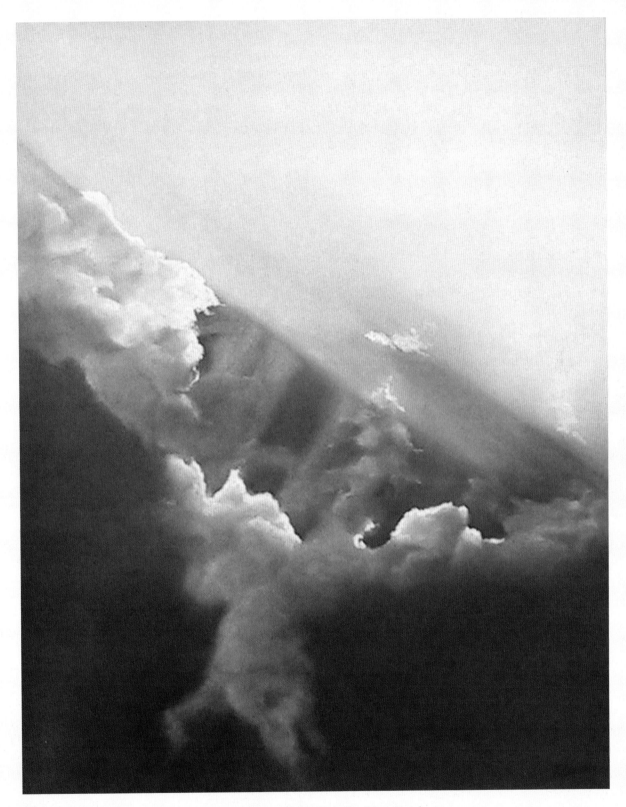

Ros Harvey, '**Highlights**'. 49 × 36cm. Pastel.

This is an example of how this break in the cloud appears in the summer, when it is higher in the sky. It will close very quickly, so I keep my eyes open for the right condition.

ROS HARVEY (Continued)

People do complain about the mess soft pastels make. It is true: everything is very dusty and I do not try to keep my studio clean. Once a year I will blitz it. Neither do I really care if the pastels get dirty. A quick swipe on my apron will clear the part I want to use. It is possible to shake them in a bag of rice if you want to really clean them, but this is not foolproof and they sometimes break. The rice is unusable for culinary use afterwards.

Supports

As I am physical with a lot of my blending, using full force with the ball of my thumb, the heel of my hand and sometimes my arm to push the pastel into the paper, so I do not want a flimsy structure.

The local blacksmith made me up a really well-grounded easel from rough measurements I gave him. It is a 40 × 40cm hollow steel section. There are two L-shaped uprights 240 × 120cm, at an 80-degree angle and cross-braced. Six holes are drilled into these 7cm apart, and I straddle an architect's board across pegs at the height I want. If a more upright angle is required, as I know some pastel artists like a vertical drop, sticky pads used for chair legs can be wedged between the upright and the board. This cost me under €100, which is a significant saving on the commercial wooden ones available.

For sketching outside – and I usually sketch the subject matter before and during photographing it – I use a small drawing board on my knee and tape the paper (any) to it. People ask me if I have been sitting out on a rock to paint the seascapes or skies, so I have to explain that after a back operation I do not like to sit for long, and that the wind and furtive light change too quickly to enable a finished painting.

Papers

This is a never-ending subject. I spent several years trying everything, and I do mean everything. Velvet, mountboard, sandpaper, papyrus, cardboard, linen, architect's board, plywood, hand-made papers from India, China, Canada, France, Germany and Italy. I tried all the different weights, colours and textures. I flirted with painted-on textural acrylic mediums.

Finally I found that a 285gsm Fabriano cold press printing paper, pinkish grey in colour, was my best bet. I buy it in 100 × 70cm sheets that I tear to size. Mostly I halve it, but my large paintings are the full sheet. There is a good deckle edge all round. The paper has an unprimed surface, so I spray it heavily with fixative before I start work. This keeps the surface from scuffing up, yet two or three layers of pastel are still difficult to lay over each other, so I again spray the under colours. This gives a good rough texture.

For small paintings under 43 × 56cm I often use a Canson pastel paper, also greyish pink, as I find this will not buckle when framed.

Fixatives

I do use fixatives. I know the arguments about deepening the tone and losing the translucency, but to me they are a really valuable tool. They will fix on to your paper the lower layers of chalk, and you can use them to darken sections of work. It is easy to 'spot'-spray small areas if they become a little overworked, and it is invaluable for adding a bit of tooth to your pristine paper. I do not use them for the final layer of work or for light areas.

Tools

My tools are limited to six essentials:

- No. 6 flat bristle brush worn down to about 3cm.
- No. 001 watercolour brush snipped off at the tip.
- Special Pierre Noire Conte pencil No. 1710.
- Razor blade for lifting out mistakes – rubber erasers make a mess.
- Tins of fixative: Windsor & Newton for hard tooth and firmness; Rowney for soft top sprays (not often used).
- A pot of 'Liquid Glove'. This is a French product available in some suppliers; I get mine direct from Lion Supplies in Nottingham. Rub a very little into your fingernails and the parts of the hand you blend with, and when you wash them, all the pigment will wash away immediately. It really saves using nailbrushes.

The Conte pencil 1710 I had used over fifteen years suddenly became just 4cm long. Panicking because I could not find the equivalent in any art shop I visited, I managed to identify just the number on the well-worn butt end. This I found on-line. It is very intense and soft, but will sharpen into a good point for detail.

Photography

In general, it is very important to learn how to understand and read the images that your camera depicts. The camera

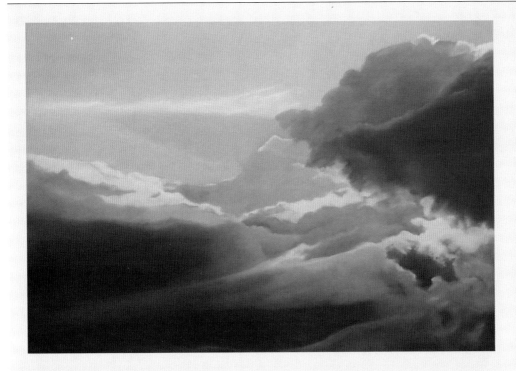

Ros Harvey, '**Donegal Sky**'.
71 × 48cm. Pastel.
My favourite skyscape, which rolls in from the Atlantic. There is such confusion here, and from the shadow on the left you can guess it is being thrown from the two clouds on the right. Therefore the sun is higher than mid-point. The abstraction of skyscapes is the greatest excitement in painting them.

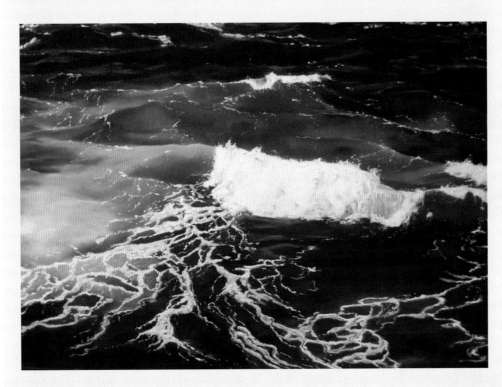

Ros Harvey, '**Mullaghmore Wave**'. 100 × 70cm. Pastel.
While waiting to sail out of a small harbour on our west coast, I managed to catch some photos of tremendously huge waves – luckily, we sailed in the other direction. There is a rocky ledge about half a mile out and these waves were breaking along them. This was a fragment, and the start of a series ('Green Wave') I have worked on for the last five years, all 120 × 90cm, framed. Although they were so far out, the excitement and memory of them enabled me to imagine them closer. I sold one of this series to the wife of a fisherman; they were celebrating their fortieth wedding anniversary. The next day she rang me, very upset, and told me her husband couldn't live with the painting as it made him feel seasick.

ROS HARVEY (Continued)

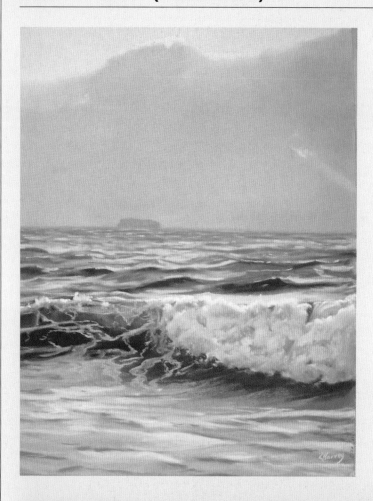

Ros Harvey, **'Wild Wave'**. 36 × 49cm. Pastel.
This is a choppy evening on our strand. I love the back-lighting and the hazy sun. I call it wild because it was unexpected: its relatives had just flopped and skittered in with no breaking power.

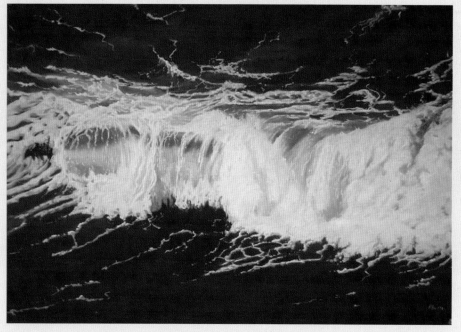

Ros Harvey, **'Breaking Wave'**.
100 × 71cm. Pastel.
Another wave from my series 'Green Wave'. I had a wonderful three days painting this: I had no interruptions and went at it for six hours each day, with small breaks. It came together nearly on its own volition. Sometimes I will re-visit one of my subject matters and paint them in a slightly different way, with a different approach, but this one, I really feel I could never do again.

Ros Harvey, '**High Island**'. 53 × 46cm. Pastel.

Here is one of my favourite sea conditions. It is rough and choppy out to sea, just around the corner to the left, but relatively calm in the little cove, with very deep water and friendly seals lounging around. Painting this type of sea can be difficult, and I have made many messes of it. I have had to get the dimply effect from a height, the light coming in, as well as the depth. The little currach, with its outboard motor, was adeptly steered alongside and gently over the large waves and swell. This remote island off the west coast of Ireland was one of eighty islands I have landed on.

ROS HARVEY (Continued)

does lie: whether it is a film or digital camera, landscapes and mountains in particular are elongated and flattened. If photographing animals, head-first is a disaster as the head is grossly enlarged. This is where sketching briefly is important: put in the mountain heights and proportions faithfully, and dot in any features that are prominent. When you then look at the camera image you will immediately understand the difference, and in time you will automatically adjust these anomalies.

In photographing skies and seas it is a bit different. I sketch very quickly bits that I find startling or unusual, anywhere, and I take a multitude of photos from the same angles and places. Of course you get excited and dash around a bit, but the more information you have, the better.

Even the most tranquil sky is moving in a direction, so the clouds usually have a little wisp or trail that will tell you, so try to get this detail.

A Brief Historical Discussion

I call my work 'paintings'. There is an argument raging about this because on the Continent pastels are called 'drawings', and I have joined battle many times with dealers, galleries and art lovers as far away as New Zealand, and even with my own contemporary artists in the Netherlands and France. I am not sure when this partisan quirk appeared, but it was certainly not used in this way before the nineteenth century.

Not only is it wrong to term pastel work in this way, I believe that some galleries and dealers think it is a cheaper option than an 'oil', and will try to reflect that in their prices. I will quote from a couple of books.

I want you to feel like you are painting while using the pastels because that is exactly what you are doing. Pastel painting is derived from a drawing technique and it remains on the border between drawing and painting.

The first mention of pastels was in the fifteenth century. However, we all know that the oldest method of painting is found in cave 'paintings', which were done with earth pigments. It was much later that a binder was added to the chalk and colour pigment to enable it to be spread and adhere to a surface.

Framing

Framing is one of the most expensive parts of the art business. It is largely made a 'trend' by galleries and interior decorators: one year it will be all black frames, the next white, then natural wood, and so on. This applies to colour in mounts, or matts. The mountboards come in hundreds of shades, textures and weights. Basically, the wider the frame, the deeper and heavier the mount, or multiple mounts, and the more expensive. Glass has become an item to be considered, too: ordinary picture glass is the cheapest and most reasonable. You can get absolutely sheer, non-reflective glass as used in television screens, which you really cannot see at all, which is vastly expensive. The more normal non-reflecting glass has an unpleasant shimmer at times and only really works if placed on the image: for pastels, which need a spacer between glass and surface, it is useless.

I frame my own work and keep it very simple. I have three ways of presenting my pastels, depending on their size of course. I usually suspend the large ones of up to 120cm on a board of compatible colour. I stick a heavy double-sided tape across the top and down the middle of the board, then peel off the protective paper and lay the painting down on to it. I leave about 4cm all round with 5cm at the bottom. It is always important when cutting mounts to make the bottom at least 1.5cm deeper than the top and sides, to balance it in the eye. If this is not done, the artwork will look as if it is dropping out.

I seldom use a coloured mount, preferring a very pale cream, or white. For the frame, I use a 5 × 4cm plain smooth-section wood. It has to have a deep rebate. Either a dull gold, or some of the lovely plain lustre mouldings on the market.

For nearly all my other paintings I will frame them like a watercolour. Double mount, cut with a 6mm inset on the outer one. Then I line with 12mm strips, the reverse cut edge of the window to make a depth when placed on the painting, which keeps the surface of the pastel from touching the glass. This is a difficult thing to avoid, as I have found some galleries or handlers will push out from behind the backing board, or pile smaller paintings behind it. It is not however, a disaster, as taking it out of the frame and cleaning it is not too arduous – just annoying.

For small paintings I have sometimes framed them like oils, and used a small scoop, glass and outer moulding, with the glass up against the pastel. Tightly pinned in so that it does not rattle around, it is secure enough.

The backing board is another decision to make. In the northern European climate, I think it is important to have a good-quality, firm 10mm MDF board, well pinned in and with masking tape over. Then a good 5cm backing tape: either watertape, or self-sticking. I use very handy fixtures that slip on to the backing board for the cords, so they are recessed.

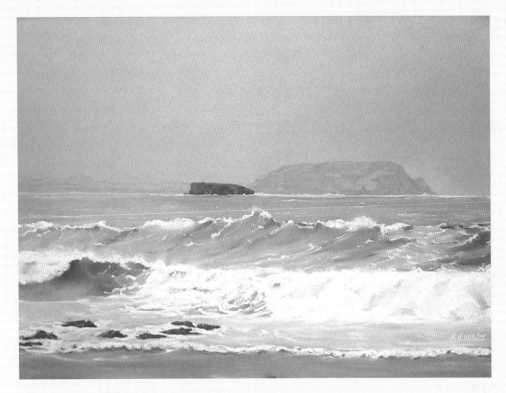

Ros Harvey, '**Morning Light**'.
49 × 36cm. Pastel.
I have included this painting because of the extraordinary eerie light. I have never seen this condition again, although I am still hopeful. I know it was early in the year because of the glow of the dried heather on the headland. For this painting I used a dark cream paper to help with the overall yellowness of the glow.

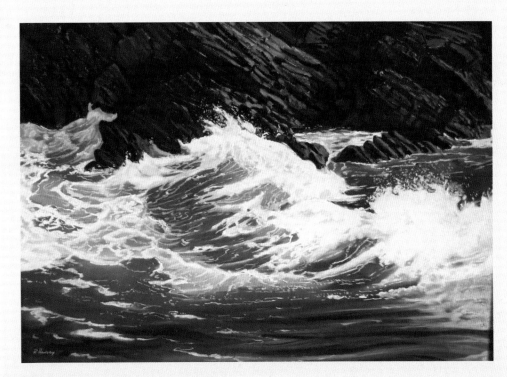

Ros Harvey, '**Running Wave**'. 71 × 48cm. Pastel.
This wave is running along a narrow cutting in the rocks. It is nearing the end of its reach and will wash up on pebbles. The backwash can be seen in the green pool at the back of the painting: this wash makes for a lot of the turmoil. I am fascinated by details like that sallow yellow/ green with the drifting foam, and the small shadow behind the rocks, that make up the full story.

Coloured Inks

I have used inks a great deal over the years. They are intensely coloured industrial dyes, usually sold in very small bottles. Its lack of popularity, except among illustrators, is probably because of its fierceness of colour. If used straight from the pot it will sink straight into the paper, and be indelibly fixed there.

It is often not appreciated just how this intense colour can be watered down until it is a mere hint or blush of beautiful delicate colour. It is wonderful for flower paintings, and for painting shadow. The appropriate tone is simply washed over our shadowed area without disturbing the work underneath.

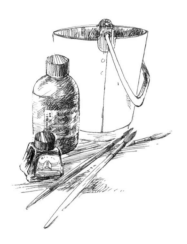

If a wash of one colour is laid down on the paper, say a blue, and a pink wash laid across that, then where these two cross a third colour, purple, will appear, owing to the transparency of the ink. If one were to try the same thing with watercolour, one is likely to get not a purple, but a brown, because the colours try to mix.

Inks need a paper that has a smooth, hard, fine clay surface called Hotpress, which first needs to be made damp with a sponge (as is often also done with watercolour work). When the ink is brushed on, it does not immediately sink but stays on the surface, giving us a chance to move it around or lift some off with a dry brush. Painting on thin card deals with this dampness better than paper, which may cockle.

In painting skies or seas, inks will give a lovely translucent quality, rather like the seas and skies themselves. On account of this translucency, we can only paint one colour over another a certain number of times: do it too many time and the colours will lose their individuality and collectively begin to show as brown.

Inks are similar to watercolour in as much as we have to know when to stop. If the painting has not worked then we just have to accept that, and not go on bullying it. With watercolour you need to be clear minded. You need to know in what order you need to lay down the colours. Applying paint in sequence like this is rather like printing. With inks there can be a marvellous fluidity. If used immediately, different colours fuse and bleed into each other.

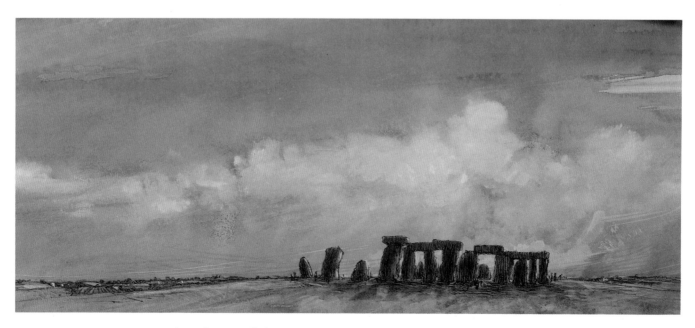

'Stonehenge, Wiltshire. Late Summer'. 60 × 20cm. Coloured inks on card.
The sky has been laid in with turquoise ink, and white gouache was touched in while still wet. Brown ink was drawn on top when dry.

Sea Painting using Coloured Inks on Hotpress White Card

Some of the materials you will need.

1. A variety of soft brushes.
2. Coloured inks. Small pots are the way to minimize the expense, but they don't go very far: you may need to double up on the yellow and blue.
3. Large bowl of clean water.
4. A couple of large white dinner plates.
5. A roll of brown sticky paper.
6. A few sheets of white Hotpress (also known as Bristol board) card. 250 or 300gsm is suitable.
7. White water-based paint (emulsion seems to work well, if it is good quality).

As this is going to be a seascape with a lot of white foam, a mixture of blue and yellow, plus a minute touch of black (to stop it looking too pretty) and a lot of water, were roughly scrubbed in with a big round brush to represent the colour of the sea under the foam. The centre of the picture was kept lighter, as a dark rock was planned to go there with much foam around it.

First rubbing in of sea colour.

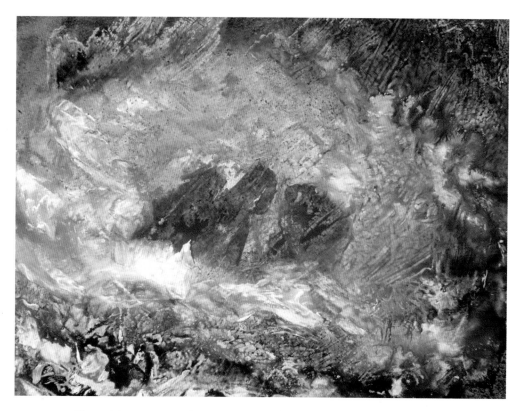

The rock has gone in and the foam roughed in with emulsion using a stiff brush.

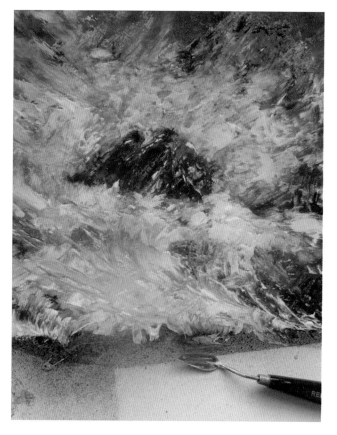

Attempting to make the foam appear as though it is hitting the rock and swirling around it.

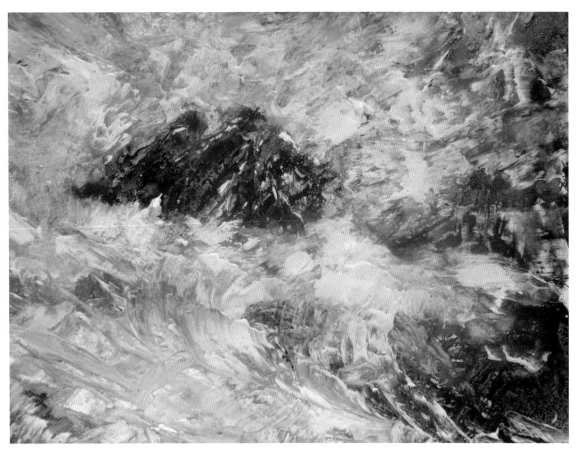

Some drawing lines have been scribed in with a palette knife.

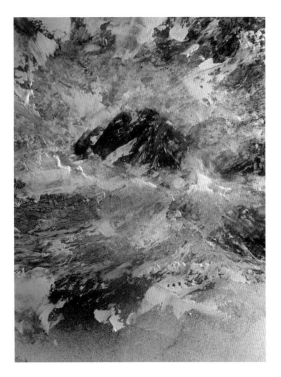

Detail showing how the emulsion has been dragged off the palette knife.

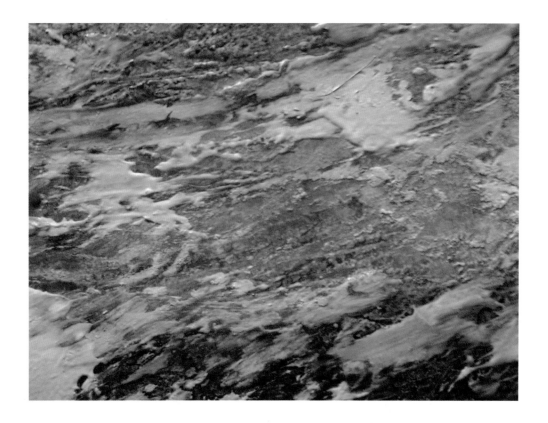

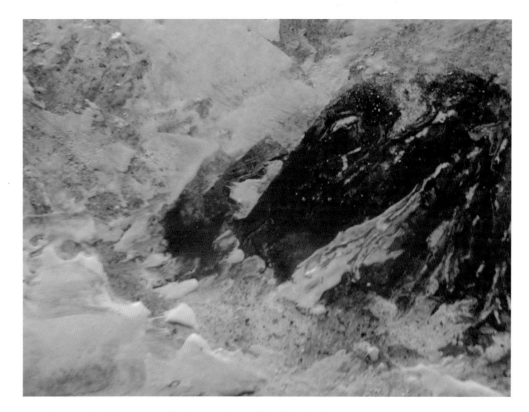

Some of the emulsion has dried and this has enabled more to be pulled off the knife with a ragged effect, rather than sliding over the top as it did when the paint was still very wet.

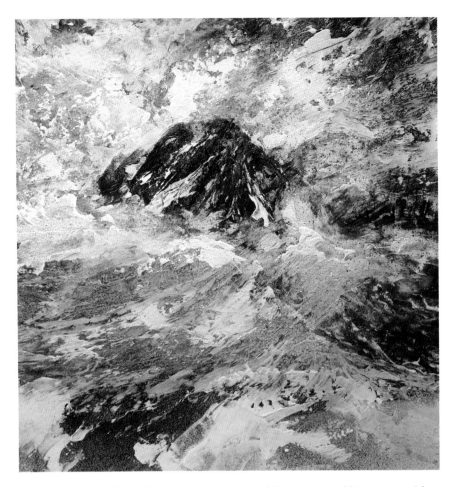

The finished painting. Although the sea isn't really working, to go on trying would just compound it even more. A last touch was to use the spray diffuser to blow some blue/green in at the edges to help the rock stay as the centre of interest.

Conclusion: an odd painting, not very happily composed but lively. You can almost hear the sea hissing. It is a useful study: I resisted my usual trick of continuing to fiddle with it until it had lost everything I had liked about it in the first place. Where the coloured ink shows through as sea and rock, the translucent nature of the ink gives a depth that another medium might not.

I have been asked on occasion why I am so against allowing brush and palette knife marks to show in my paintings. What does it matter if the viewer sees them – isn't that more interesting? Perhaps it is because, for me, obvious brush marks and the like can spoil the 'direct impact' of the painting on the observer.

In this painting I would like to think that the observer's own memories and impressions of the sea would be triggered. When the mechanics of how the painting was put together are very apparent, the magic is lost. Instead, a kind of 'intellectual appreciation' of the sea is substituted – a much lesser experience.

When painting with inks, you need to wash your brush thoroughly before dipping it into a pot of another colour, otherwise the colours will degrade, particularly the yellow. Therefore, a large pot of clean water needs to be handy. Inks are best bought in 250 ml pots and only enough for immediate use poured out into a saucer or similar. It is unwise to pour back into the large pot a colour that has degraded, even if only slightly. Another thing about inks is that you can draw on top with a pen if you feel some part of your painting needs some extra definition. You then have the atmospheric washes of colour setting the scene combined with the line drawing detail pulling it together. Most satisfying!

If you have never used coloured inks I can only encourage you to try. They are thrilling.

Drawing with Dip Pen and Black Ink

There is tremendous pleasure to be had drawing with pen and ink. It is surprising how different people will handle it differently. It is interesting to look at pen drawings of the turn of the last century, the great age of superb work from illustrators and cartoonists right across the globe.

For the purposes of this book, however, which is intended to encourage readers to try mediums that might be new to

them, it is best just to look at pen drawing as it relates to skies and seas. In some ways pen and ink don't lend themselves readily to huge airy skies and turbulent seas, because to get different shades and textures the pen needs time to delineate them, its line being so very fine and only able to carry a minute amount of ink. Nevertheless, it is impressive just how much it can do.

The most sensitive nib is the mapping pen nib. The lovely thing about this little nib is its sensitivity to the slightest changes of pressure from the hand. It faithfully records changes of speed, of direction, of hesitation and of repeated long and short strokes – it is a bit like a graphic tachograph.

Its needle-like tip can catch in the surface of the paper if is forced into a sudden change of direction that it can't cope with, splatter ink and become crossed. Once that has happened, nothing will persuade the nib to work properly again. A smooth Hotpress paper or card will help minimize this, as will the best-quality typing paper.

All the black and white drawings in this book have been done using this mapping pen nib. The other small nib in the picture is very similar but slightly stiffer, possibly preferred by someone working quite slowly. The third, larger nib has a thicker, slightly rounded end: being fairly rigid it tends to leave a fairly constant line, not so expressive. It is possible to get a very similar fine line with roller ball and fine fibre-tipped pens from stationers. These would also have the advantage of not needing to be constantly replenished at the ink pot.

If you have left the top of your ink bottle off for some time while you draw, it is possible for the ink to lose a tiny amount of its moisture through evaporation, especially in the summer, causing the ink to be a little more sluggish as it is drawn off the

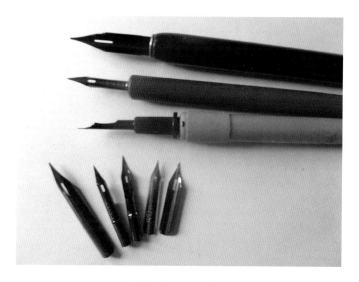

Mapping pen nibs.

nib. The line breaks up and doesn't quite complete its stroke, forcing you to go back and duplicate. The drawing will be losing its freshness: just add a tiny drop of water. The same thing can happen if you have started drawing high up on the page and, as you come further down, a tiny film of grease from your drawing hand has made the surface of the paper slippery: the nib can skid over this without leaving a solid line. Resting your hand on a loose piece of paper can prevent this.

It is traditional when starting with a new nib, before slotting it into the pen, to rest the point carefully on the tongue and pull it out between closed lips. I don't know why this is done: perhaps it is what our forefathers did with their quill pens; maybe it helps the ink slide off the new nib in some way. I'm happy to do it, anyway.

This has got to be the best possible age in the history of pen and ink drawing. Pens, inks and papers have never been more available or more sophisticated, yet at the same time, very few people draw now and it is hardly taught at all.

Acrylics

Acrylics are a very powerful, versatile medium. They can go from transparent to opaque, from thin to thick and back again all in the same stroke. They can be used like oils or watercolours, are fast-drying and can be used straight from the tube. The drying time can be extended by dampening the paper before painting. Transparent glazes can be built up in thin layers and the flow improved by 'flow improver medium'. Colour remains vibrant if rainwater is used. Acrylic gesso is used for priming and usually takes two or three coats; if a loose piece of canvas is pressed into the last coat while still wet a rough canvas effect can be achieved.

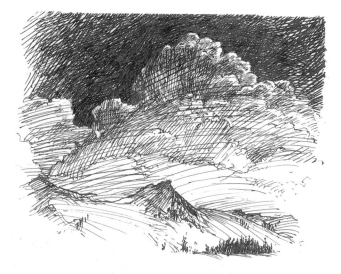

My use of the tools and materials in my painting could be seen as 'cavalier'. That is, that I am happy to use any tool or material, in any combination, to achieve the effect that I want. You will recognize there is a distinct bias toward the methods and materials that I have come to like and respect.

Oil Paints

The oil paints I use are the Windsor & Newton water-mixable oil colour 'Artisan' range, which can be diluted with turpentine or water. This is a very clever paint that can be thinned with both – you could probably use them as a watercolour paint, although I have never done so. It is made for solvent-free oil painting. The human body can absorb turpentine through the skin, and solvent fumes can cause all kinds of damage: this paint was devised to get around this hazard.

Another important feature of this paint is that the colours are strong, clear and sharp. It is currently sold in tubes of 37ml and 200ml, though occasionally I buy smaller tubes of artist's colour to highlight and enhance. Cleaning brushes thoroughly can be done with warm soapy water.

It is also possible to get titanium white powder from proper art suppliers, or from mail order/internet suppliers. With this you can put a little out on to a board and, by adding a small amount of linseed, make white oil paint up with a palette knife to the consistency needed for the painting. It can also be sprinkled on to the white paint already on your painting, giving a dry or rough texture, or even to suggest sea spray. If you use a lot of white paint then this will work out considerably cheaper than buying it in tubes, but it is still worth having tubes available.

The best aspect of this paint is that you do not have to be frugal with it. It does not inhibit your painting out of concern for its cost. We are freed from all that.

I know of another painter who is quite happy to use household paints in tins and thicken them with a painting medium. I have tried this, but it is not for me and I am not sure how stable the resulting paints are for fine art use.

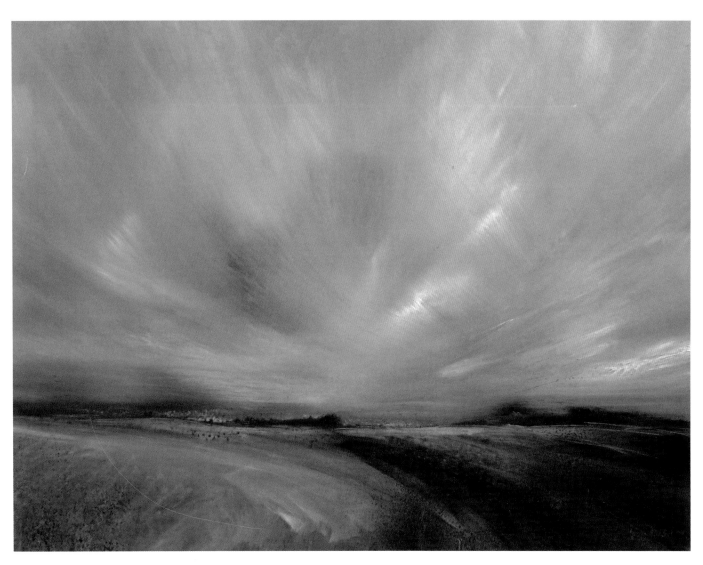

'Winter Fields overlooking Wareham'.
Painted outside on a bright, late autumn day that was very calm.

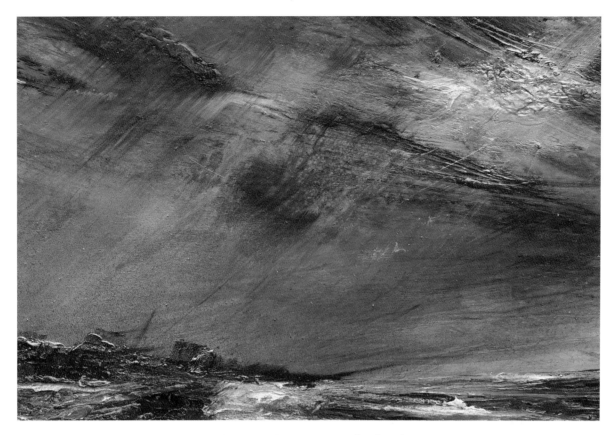

'Winter Storm'. 110 × 40cm. Oil on board.
From a photograph taken from the beach, and painted the same evening.

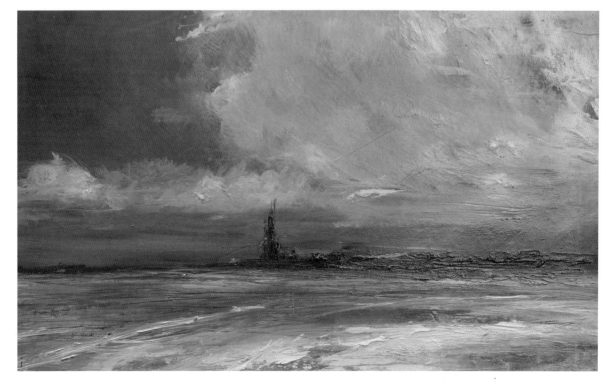

'Evening, Sandbanks, Dorset'. 100 × 38cm. Oil on board.
Taken from some rough drawings before the mist rolled in and the scene was lost.

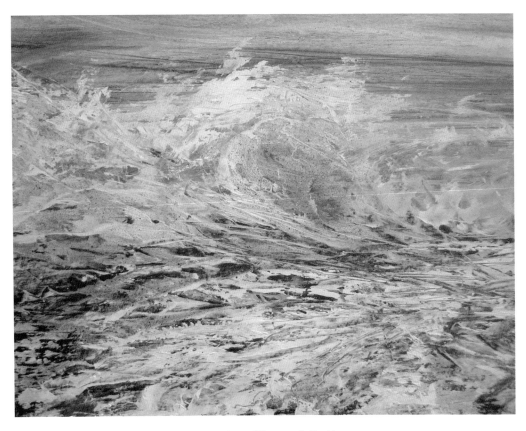

60 × 40cm. Oil on card. (Both)

These two paintings are of the same wave, or at least, watching how succeeding waves behaved on the same little patch of rock. The wave would rush in and dash itself against a submerged rock (above), and then withdraw and sink down a hidden hole and send up a plume of spray as it disappeared (below). It became very funny just watching and listening to this happening.

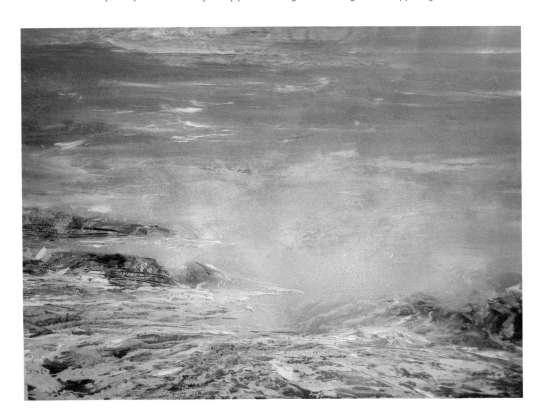

ANDREW LIEVESLEY

My landscape paintings are a response to the scenery I see on my many long-distance walking trips throughout the UK and Europe. Usually painting in acrylic, but sometimes with a content of mixed media, I endeavour to add an element of abstraction to my interpretations of wild scenery.

Source Material

I spend a lot of time looking at sky and sea, studying them in depth, thinking about how three-dimensional observations turn into four dimensions. Also, because my other interests are walking and photography I make a lot of reference images on my journeys. My work has a content of abstract with each picture, so my aim is not to create a replica of what I see, but to capture the essence of the scene.

Materials

For sky and sea my acrylic paint pallet includes ultramarine, cobalt blue, light ultramarine, coeruleum blue, burnt sienna, oxide yellow, warm grey, buff titanium and titanium white. I also use the black, sepia, white and indigo acrylic inks in sea pictures, the last mixed with a little black to tone it down.

To apply the paint I use 25–50mm flat brushes, palette knives large and small, and kitchen roll. Support material is either heavyweight paper, hot press paper or MDF. I usually apply a coat of gesso on both, but it is not vital on the paper.

Sky

Whatever I am doing, I will look at a lot of source images of my own, and also produce a simple sketch to establish where everything is going to be placed in the picture; a vague understanding of where the horizon line is going to be placed is then marked out on the support. I have the key image on a large computer screen next to my easel and others on a computer screen behind me. I frequently look at lots of images as I work to make sure I remember the 'atmosphere' when I originally looked at the scene.

I then paint the sky. This will be applied with a large brush with a lot of different blues and burnt sienna. I then usually put some white on a big, flat palette knife and start bringing direction into the sky; this also has the effect of calming down and lightening the different blues. At this stage I also might add a small amount of other colour. I will then work with a mixture of brushes, palette knives and paper kitchen roll to get the different effects that I want. I also use a water spray to create dribbles and different textures.

I will usually let the paint dry and come back to it again in a couple of hours to either alter or tighten up any detail: remember that above you the sky is 'bigger', but further away near the horizon you need more detail.

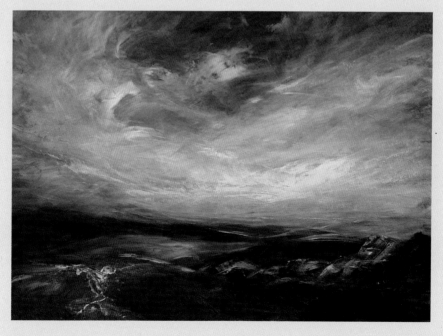

Andrew Lievesley, path 18, 'From Longaford Tor, Dartmoor'. Acrylic.

Sea

I will often put down a warm colour background that might only be occasionally glimpsed as rocks or sand underneath the intended sea area, although little of it will be seen.

I now use a mixture of inks liberally dribbled on to the paper or board, which is tilted to get the effect I want. I also spray water into the ink to help it run and mix together: adding sepia ink into the blue, black and white mixture can create a blue/green. I then let this all dry overnight. Remember that acrylic ink is water-resistant and not waterproof, so any additional water might disturb whatever patterns you have.

The next day I will then add the detail to the sea, which I usually do with a flat brush, using its edge as well as flat surface. I also use palette knives and kitchen roll to get different effects. This painting can be a fast-moving abstract affair as you try to capture both the different densities and the moving nature of the sea. If my painting is of 'wild' sea I will try to avoid a horizon, but thought needs to be given to blend sea and sky together.

Once again I let the painting dry before using a big round brush loaded with wet paint to spray and flick marks on to the surface; it is easier to have a dry painting to do this with. Because of the random nature of the activity you often have to remove the marks with a kitchen roll.

Land

If the picture has land or scenery in it I will then paint this in, using a mixture of techniques and a different pallet of warmer colours. Most of my landscapes are from the wild parts of the country with distant horizons, so one of the key activities at the end is to blend the sky into the land.

Finishing and Framing

Framing is one of life's black arts. As one gallery owner told me, 50 per cent of the time you are going to be wrong in the customer's eyes, so do what you think is right. Framing styles also vary a lot within the country, and are driven by local fashion. However, here are a few of my own personal thoughts for my style of painting.

1. I like to 'intensify' the colour, so I either like the work to go behind glass or finish it off with a semi-gloss varnish.
2. Framing needs to be as neutral as possible to appeal to the maximum number of potential customers, but must also be appropriate to the painting.

3. If the painting is going behind glass I like at least an 80mm mount around it – never coloured, always white.
4. If you are selling your work, framing cost must be considered as part of the price you expect to receive.
5. Do not frame too much work unless you have potential homes or outlets for it. I know of quite a few artists who have hundreds of pounds' worth of framed work sitting in store.
6. If the work is going to a specified home, try to pick a frame that appropriately links the painting to the wall and the rest of the room's decorations.

Acrylics

Acrylics are the very powerful pigments that suit some painters well. They have the physicality of oil paint but with the added gift of being drier and firmer, and able to be manoeuvred by a palette knife with tremendous effect. Add to this their equal ability to display themselves as a delicate wash and, at the same time, go from opaque to translucent and back again in the same stroke, and we know that we are looking at a very versatile medium.

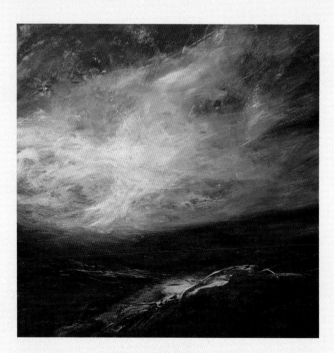

Andrew Lievesley, path 45, **'On top of the Moor, a view from a tor on Dartmoor'**. Acrylic.

ANDREW LIEVESLY (Continued)

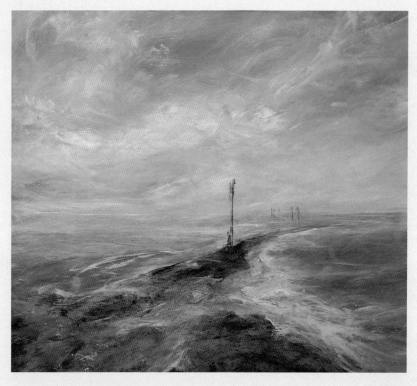

Andrew Lievesley, 'Porth Kidney Sands. Looking through the Sea Fret, near St Ives'. Acrylic.

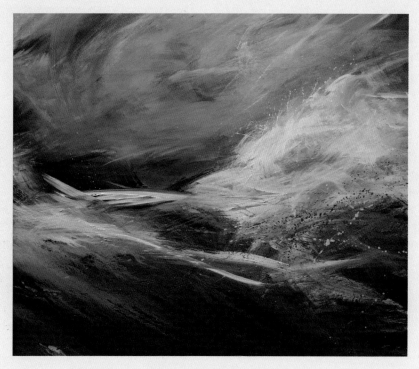

Andrew Lievesley, sea 3. Acrylic.

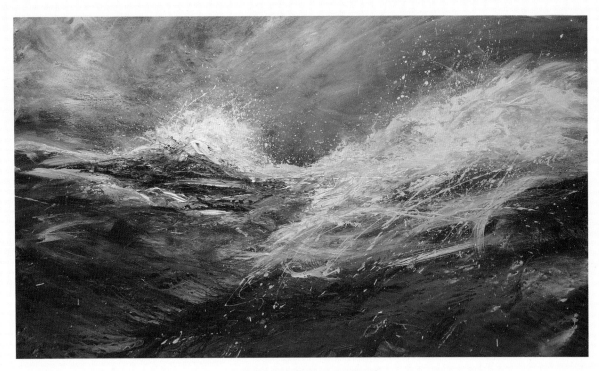

Andrew Lievesley, sea 5. Acrylic.

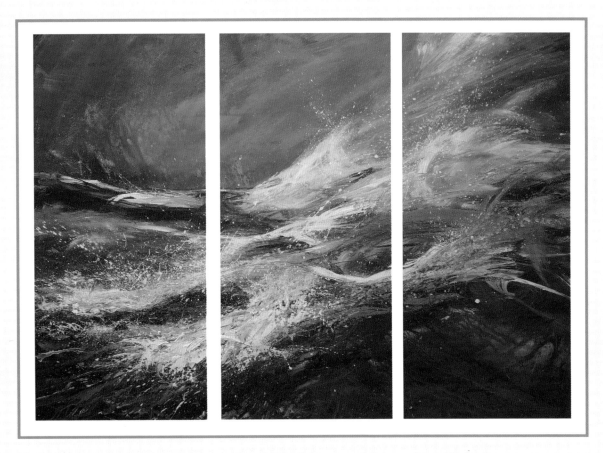

Andrew Lievesley, sea c5, 'Tryptch. The Tribbens, near Sennan, Cornwall'. Acrylic.

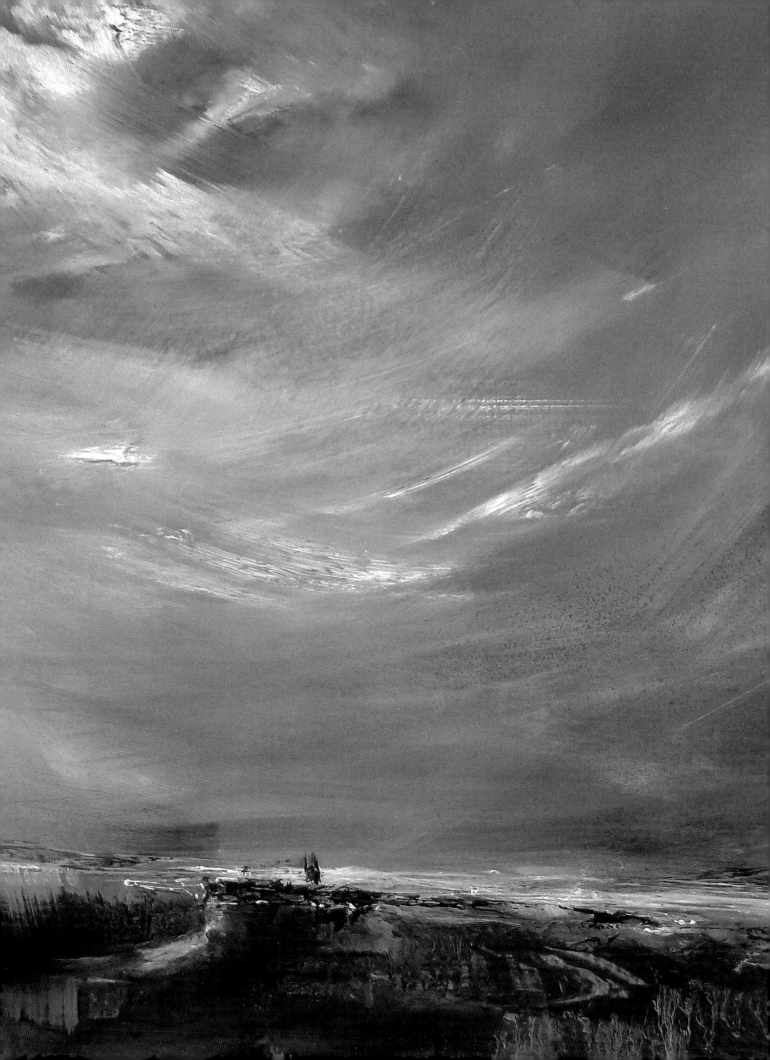

UNDERSTANDING LIGHT AND COLOUR

I believe that the light in a painting has to be alive. Not necessarily lively, but 'alive'. It needs to be seen as coming from somewhere, and to be going somewhere, and to be having an effect.

Nobody could possibly know all that the light is doing. Nevertheless, we have been looking at, and been affected by, light since the day we were born, and part of our brain knows perfectly well how this light behaves and how objects behave when illuminated. It is this part of us that will confirm the rightness of a painting and be unable to open itself to a painting if these 'light laws' are not operating correctly. I believe this happens to all of us, whether we know it or not.

Perhaps the reason that we don't seem to know much about the effects of light in our everyday lives is because we don't need to. As long as we can see clearly enough to do what we have to do – e.g. the bus coming up the road is a 14, not a 22 – then evolution stops there. Consequently our eyes haven't developed beyond that point either.

Artistically inclined people, however, have a real interest in light. Our minds are often trying to work out how some shadow or streak of light has come about. On the phone, for example, part of the mind is attending to the conversation, another part is trying to work out why that chair leg is throwing three sets of shadows.

There are painters whose paintings are imbued with light: they seem to invest light into everything they do. Van Gogh's simple, thick pen marks in his drawing of the orchard, for instance, are saturated in light. There are also painters whose paintings are quite opaque: light is added on top like a dollop of ice cream.

It has often surprised me how intensely blue a shadow can be: so blue that I have hesitated to paint them in so strongly, even though I know they are there. These blues are being illuminated by the blue of the sky, which comes right down to the surface of the earth.

The fierce light coming from the sun is white light that is made up of all the differing wavelengths or photons, the shortest being the blue and the longest being the red. These and the wavelengths in between make up the colours of the spectrum.

As the sun's light passes through our atmosphere – which is itself composed of molecules and atoms of gases, moisture and dust – the shorter waves of blue collide with atmospheric particles and are scattered and redirected, like billiard

balls. This scattering of the blue photons is the colour our atmosphere takes up. The red wavelength pushes on through and is unaffected until it hits the top and bottom of our spherical atmosphere where the journey through to the surface of the earth takes longer, the atmosphere being deeper there.

Now it is the red wavelength that is scattered. At dawn and again at dusk, our sky has taken up the orange and reds that can be so spectacular, especially when the sun has dropped below our horizon and is illuminating the underside of clouds. In the opposite part of the sky the blues are still apparent and are backlighting the same scene.

Once we start inquiring in this way, asking questions like 'Where is the object that is reflecting a colour on to a surface of another thing and changing it?', 'What is the colour of the road that we are driving on?', then there is no end to this sort of looking. Car and train journeys become very absorbing, as do sitting in cafés or sitting at a desk or in the barbers. The lift we can get when the headlights of our car at night reflect in puddles or a stretch of water, and then bounce up into the underside of trees opposite.

We are treated to an unending natural theatre show. Why waste these free tickets? It is this sense of theatre that needs to inhabit our paintings. It doesn't have to be high drama, but there should be a story there. Like any story, it needs a main character to carry the story and be supported by a secondary cast that, even though they have stories of their own, sublimate those stories to support the main agenda.

Paintings don't reach their full potential when everything in them is trying to draw attention to itself, like every actor on a stage acting independently of the others. Some kind of editing has to go on in a painting: some things have to be sacrificed in order for the main event to make maximum impact. The role of light and colour in this is paramount.

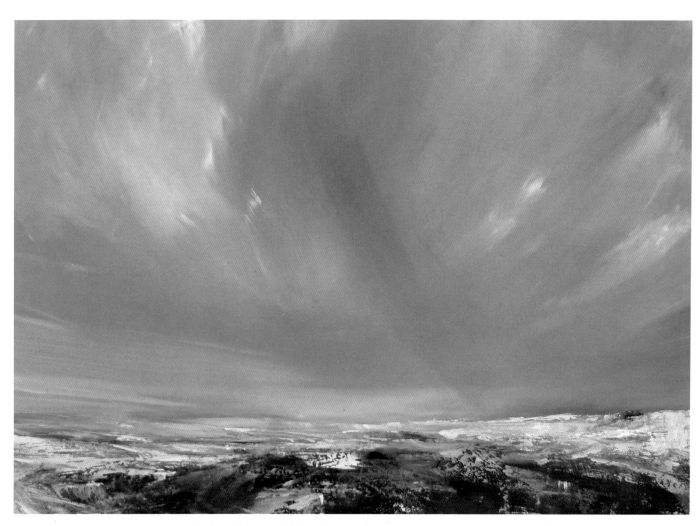

'Iceland'. 110 × 62cm. Oil on board.
The turquoise blues of the snow and ice have to be seen to be believed. This painting was started outside but the paint stiffened in the cold, so it was finished in studio.

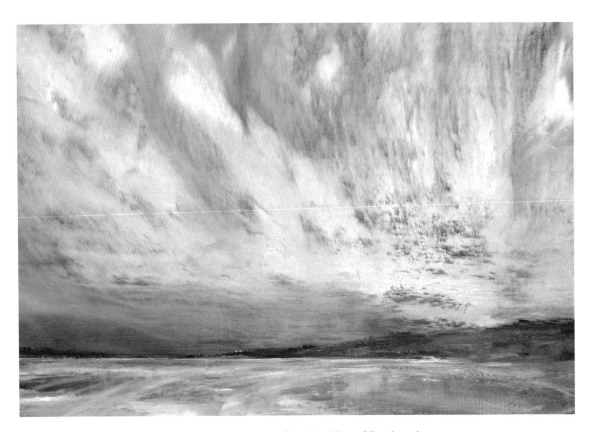

'**Iceland. Volcanic Beach**'. 120 × 72cm. Oil on board.
Cloud hit by bright, hazy sunlight.

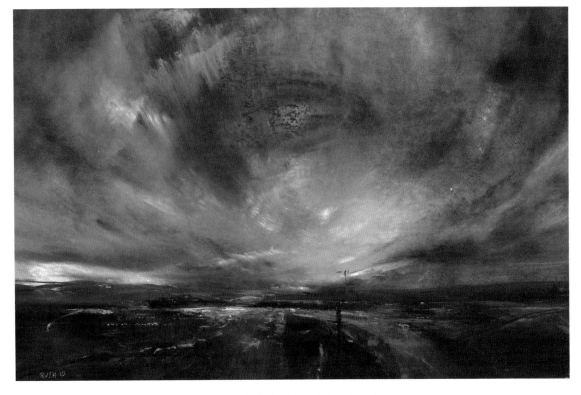

'**Iceland**'. 118 × 76cm. Oil on board.
Taken from a photograph just after a storm. Everything glistened. Slivers of light intensified the colour in pockets of land as the light drew from the sky.

RACHEL SARGENT

I studied painting at the Roehampton Institute, University of London, and graduated with a BA (Hons) degree in 1981. I returned to my native Dorset in the mid-1980s since when the stunning Dorset landscape has been my inspiration.

I am absorbed with the way light changes and defines places, constantly transforming the same piece of land, wood or coastline. This changing quality of light against the permanence and stillness of the landscape is central to my work – clouds across a hill, flashes of light through woods, shadows along a track or the sun against the horizon for instance.

I use mixed media with materials such as water-based paints, oils, wax, crayons, collage and emulsions. I build thin layers of paint, and rub and scratch through them to reveal colours and textures underneath. I often begin by making marks and using the accidental effects that occur in the process to suggest the direction the work may go in.

I exhibit regularly during the Dorset Art Weeks and the Wylye Valley Art Trail. I have shown my work with a number of galleries including the Alpha House Gallery in Sherborne, the Maltby Contemporary Art in Winchester, the Wessex Fine Art and Ceramics in Wareham, the Black Swan in Frome, the Mall Gallery in London, the World's End Gallery in Chelsea and the Royal West of England Academy in Bristol.

I have recently moved studios and now work from a converted cowshed at Gold Hill Organic Farm in Child Okeford, where I also run workshops in landscape painting.

Seas and Skies

I find it difficult to describe my approach to painting seas and skies as I try not to follow a standard formula in my work. Using a combination of materials and working layer upon layer, my paintings tend to evolve through a series of random and controlled processes. I am always experimenting with different ways of starting a painting. For instance, I enjoy creating textures from thick emulsion paint or plaster, layering thin washes of paint over the textured surfaces, sanding, rubbing, scratching and scoring into previous layers or perhaps masking off areas to emphasize a certain line or shape.

I use a variety of surfaces such as very thin newsprint paper, cartridge paper, mounting card, hardboard and MDF, or indeed any other odd things I can pick up from the local scrap store. Materials consist of household emulsion paints, tester pots, acrylics, water-based printing inks, pastels, crayons, oil paints and varnish. Other aids include candles, cooking oil, latex rubber adhesive and petroleum jelly.

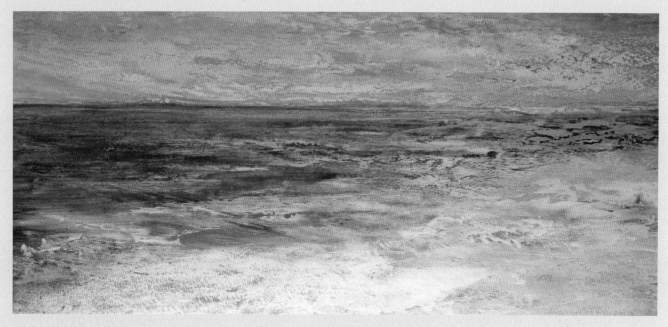

Rachel Sargent, '**As we were leaving**'. 40 × 25cm. Emulsion and acrylics.

Rachel Sargent, '**Rock Spray**'. 30 × 40cm. Emulsion and acrylics.

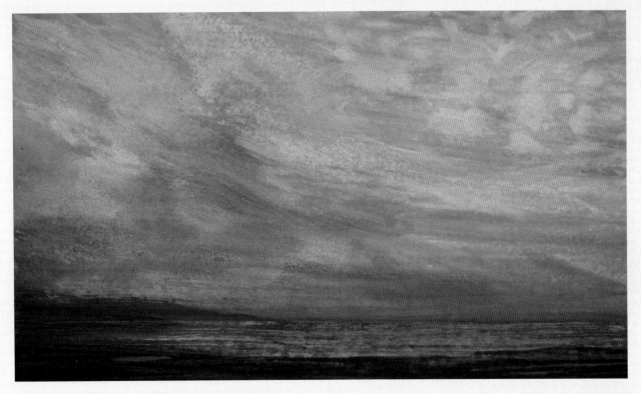

Rachel Sargent, '**Day Break**'. 30 × 21cm. Emulsion, acrylic and crayon.

RACHEL SARGENT (Continued)

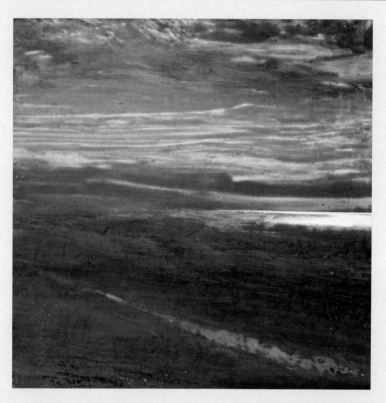

Rachel Sargent, '**Drawing up Light**'. 42 × 42cm. Oil and varnish.

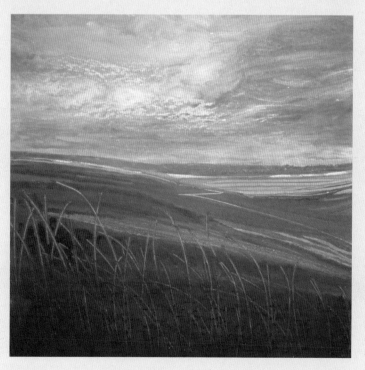

Rachel Sargent, '**A Lark's Sky**'. 50 × 50cm. Emulsion, oil and acrylics.

All the time I am looking to create the atmosphere and mood of a place rather than an accurate visual representation. Like a chef without a recipe, I am continually adding and adjusting things until I feel I have achieved the desired effect. Each layer is a gamble (it might work, it might not) but I try not to be discouraged when it seems to be going wrong, as something there may give an extra depth or quality at a later stage. Of course, some paintings are never concluded and have to be abandoned. I do, however, keep them for possible recycling at a later date.

I am a keen walker and love being out in the elements. While walking I am absorbed with looking at the light: the patterns of light and shade, glimpses of light through trees, shafts of light breaking through clouds, great floodlit areas or single spot-lit glints on the sea. The sea and sky are natural sources of inspiration for me. I love to stand in one fixed place and look out to the sea and sky. It is never the same: it constantly changes as the theatrical drama unfolds like a stage set lit from different angles creating atmosphere and evoking emotions. This is what I try to convey in my work.

My main concern is to get light into the painting, and so I often start by using brilliant white emulsion paint and brushing it on thinly in some places but thicker in the areas where I want the light to be strongest. These initial marks and brushstrokes often set the blueprint for the painting as they are usually visible despite the subsequent layers (unless very thick) or at least are revealed when lightly sanded down with a piece of wet and dry paper. Where the emulsion paint has 'primed' the surface the subsequent layer of paint, if thin enough, will be absorbed into the surface in different ways. This starts creating depth and texture.

Another way I build up layers is by using wax resist techniques. Rubbing a candle over a blue-painted surface, for instance, and then painting over it with a thin white wash can create some lovely watery or cloud-like effects. Similarly, a smear of petroleum jelly or oil under a wash of acrylics will produce an interesting result as the oil and water resist each other. Another way might be to paint some areas with a latex-based rubber adhesive (a cheaper version of masking fluid), and leave it in place until the end before rubbing it off and revealing it untouched by subsequent layers – this is particularly good for retaining white highlighted areas. Often I will work on top of the painting, refining areas with crayons or pastels to add more colour intensity and definition.

Rachel Sargent, '**A Blustery Day**'. 20 × 20cm. Emulsion, acrylics and oils.

RACHEL SARGENT (Continued)

In the following section I will explain the methods I used to create three of my paintings. Each was approached slightly differently.

'Another Start'

1. This was painted straight on to a sheet of MDF.
2. I cut the silhouette of the hills from a sheet of newspaper and held it in place with masking tape at the bottom of the MDF.
3. With the shape of the hills masked off, I painted the rest of the MDF with sweeping strokes in white emulsion to create the movement of the clouds.
4. I laid a straight piece of paper along the horizon line, and with my finger rubbed in the sea with thick emulsion paint.
5. I removed all the masked-off areas and, when dry, painted over with thin layers of acrylic paints using blues, greys, blacks, ochres and greens.
6. With more white emulsion paint I brushed and sponged in the next layer of clouds.
7. When dry I sanded down the areas I wanted to have more light in.
8. Finally I scratched through the paint with a sharp knife to suggest the movement of grasses in the foreground.

'A Rough Sea'

1. On a piece of perspex (you could use any shiny surface, such as glass or sheets of acetate) I painted loose, bold strokes using watery acrylics and thicker white emulsion paint, mixing them together in places and just letting them swirl into each other.
2. Using my finger I drew into the wet paint a horizontal line for the distant hills, and some more for the movement of the waves.
3. I took a thin sheet of newsprint paper, laid it in top of the painted perspex and pressed down to take a monoprint (a one-off print) from the surface. This gives a quality difficult to achieve any other way.
4. When dry I added acrylic washes of blues and greys over the entire surface, letting them settle into the paper and be absorbed in different ways depending where the emulsion paint was.

5. Then I lightly sanded over the paper, revealing the thickest of the white emulsion, defining the clouds and waves. Because the paper was so thin the sanding created small holes in the paper that added to the effect of spray and sense of the salt air.
6. When it was dry I brushed a thin layer of adhesive to the back of the paper and stretched it on to a piece of mounting card, smoothing it down from the centre outwards to avoid bubbles and creases.

'A Break in the Clouds'

1. I painted this on textured vinyl wallpaper.
2. I painted the entire surface with white emulsion paint, making marks with my brush to create movement.
3. When dry, I washed over watered-down emulsion paints, using pinks and mauves, into the sky.
4. When dry, I mixed Payne's grey and Prussian blue oil paint together with a polyurethane varnish (do this in a well-ventilated area), and covered the entire surface.
5. While wet, I wiped over the areas in the sky, with a rag, to remove some of the paint/varnish where the light is breaking through the clouds.
6. When dry, I tore a piece of paper and put it over the bottom of the painting, and rubbed white emulsion paint above the torn line to define the foreground.
7. With the torn line still in place, I put the edge of a straight piece of paper along the top of the horizon and painted in a thick strip of emulsion paint for the sea.
8. When dry, I sanded down the foreground area to reveal the textures that were on the original surface.

Rachel Sargent, '**Another Start**'. 60 × 120cm. Acrylics and emulsion.

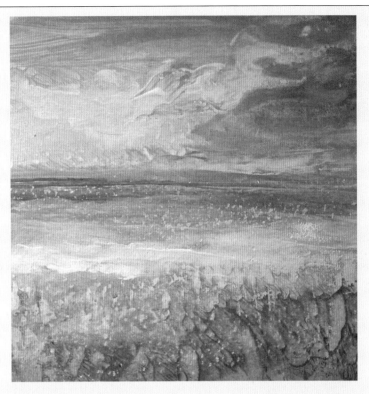

Rachel Sargent, 'A Rough Sea'. 40 × 40cm. Emulsion, acrylics and pastel.

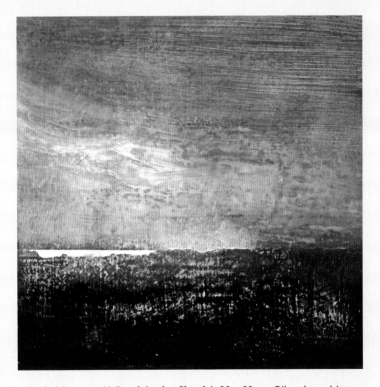

Rachel Sargent, 'A Break in the Clouds'. 50 × 50cm. Oil and emulsion.

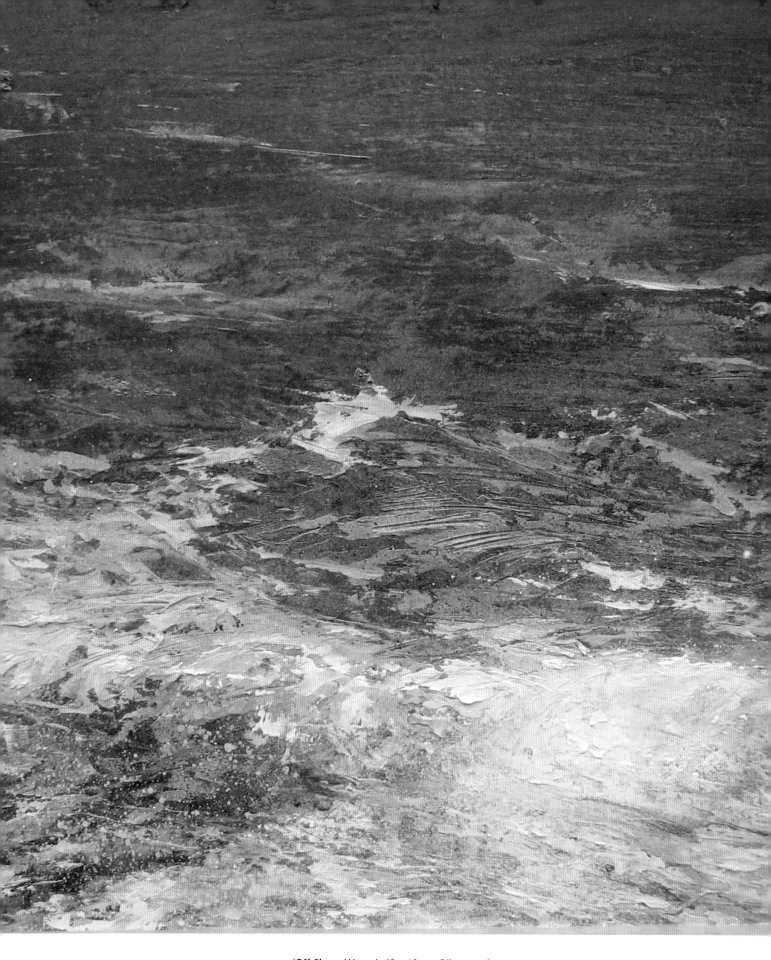

'Off Shore Waves'. 60 × 40cm. Oil on card.
Looking on to the sea from a rock at Portland. The bright reflection is suggested by dropping white titanium powder on to the wet paint.

SEA PAINTING

I am primarily interested in the sea and the sky for themselves alone. The physics of them. Rather than use the sea as a stage set for ships and so on, or the sky simply as a backdrop.

I have said elsewhere that to paint seas and skies you have to be very interested in them. Not only just how they look, but why it is that they look and behave as they do. If we make this inquiry into why they are acting (and acting on each other), this is high protean food for the mind and the mind will start looking for more of the same. This new information will get into the painting. A wave or a cloud will naturally have more authority without us having to strive for it.

It may be that the reverse is also true. If the mind hasn't been given the information, it will have nothing to draw on. It is bankrupt.

We need to look and look at skies, and try to work out what is going on there. We need to go and visit seas, holidaying by them, going and living by them, take up fishing or sailing, even become a lighthouse keeper: anything to build up a massive storehouse of imagery and experience to be called upon. Even if you can't do any of this, we still have experiences from childhood that can be woken.

Failing all of the above, there are films, photographs and stories.

The great challenge in painting the sea is getting the following four things to work together, or at least, not contradict each other:

1. Capturing the translucency of water.
2. The movement of waves.
3. The foam riding on top of water.
4. The sense of the perspective.

And lastly, check the colour of the sea – anything from khaki through the green/blues to grey and black.

The challenge with point 2 is to get the waves all to look as though they are being moved forward by the same energy, even when they are in retreat.

The challenge with point 3 is getting the foam on top of the wave in a way that helps describe the form and the structure of the wave that it is riding, and what that wave is doing or what has just happened to it. Also, the white of the foam is not all of the same intensity.

It would be possible to deal with all of these if we set about it by study, care and forethought, but how often does this happen at the expense of immediacy and movement? Without the feeling that the wave has just drawn itself up and its crashing down is inevitable, then we have missed its essence and it is but a suspended thing, fixed, frozen, made of plaster.

The right approach in painting would seem to be to suggest the waves and add foam, as this is the way it is happening out there in the sea itself.

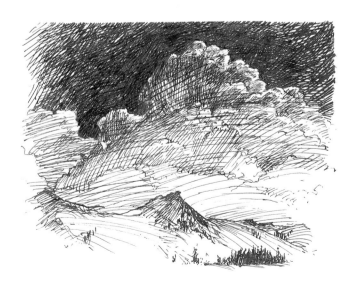

'A lonely rock off the Isle of St Kilda'. 55 × 34cm. Oil on board.
On a quieter day it can be covered by sea birds.

'Sandbanks, Summer, Dorset'. 88 × 36cm. Oil on board.
A shallow tide races in quickly.

'**Portland Bill, Dorset**'. 40 × 28cm. Oil on card.

Catching the intensity of the wave's foam. A wave has hit a rock face and, falling back, has clashed with the next breaking wave behind it.

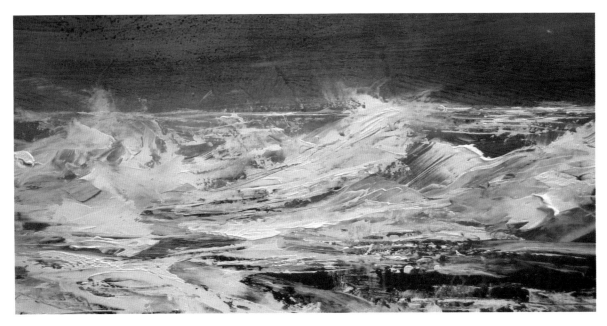

'**Crashing Waves**'. 40 × 60cm. Oil on card.

Waves were rushing in, far quicker than usual. I don't know why. There was no strong wind.

Painting in Oils on Good Quality Mounting Card

This is a method that I have devised to help deal with the problems outlined earlier. A friend, a framer, gave me some large offcuts of mounting board – the centre pieces left after she had taken the surrounds. Many of them were quite large, cream-coloured and good quality.

As an experiment I mixed blue/green oil paint with a lot of raw linseed oil in a jar, and painted on to the card with a soft brush. Although the colour was a lovely dark, rich green with the first few strokes, within seconds it had completely disappeared as the oil sank into the card.

Another coat followed the first, also leaving hardly a trace, and a third coat took a little longer before sinking. The fourth coat stayed longer and the colour remained strong enough to push into possible wave-like movements; later it was possible to elaborate on the waves by adding detail and more colour. All of this took no more than ten or twelve minutes. It didn't seem necessary to wait for one coat to dry before adding the next.

To mimic the 'foam' a palette knife was loaded with soft white paint – emulsion seemed to work quite well, but oil paint was a better, sharper white. I marvelled at how it skidded across the slippery surface, leaving a convincing trail of swirls and tiny bubbles, sometimes composing themselves in little eddies. I was also surprised to find that this rather soft, slippery surface could be worked with a palette knife, shifting and sweeping paint around, lifting off white paint and revealing the dark green beneath. The surface of the card appeared to be able to take any amount of working without scarring or deteriorating.

Tones and colours did change slightly as the oil dried, but in some cases this only served to improve the painting by making the tones a little softer and more subtle. It seems possible to go on and on working on this painting, if you feel you need to. The great gift of painting like this is that there is no suggestion of a brush or a palette-knife stroke. It looks untouched by hand, not 'man-made' at all. This relieves the viewer of the need to be impressed by the skill of the painter: he or she can just go ahead and enjoy it. It will not work if we don't really know what the sea looks like in the first place: the paint cannot do that for us.

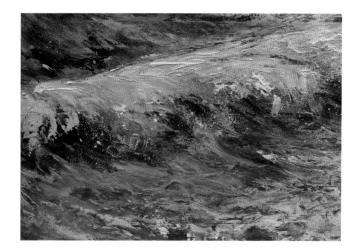 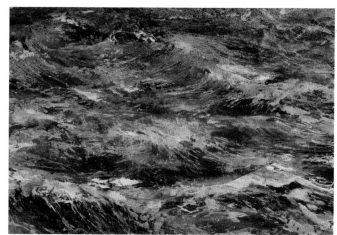

Painting Waves

Demonstration: Painting on Card

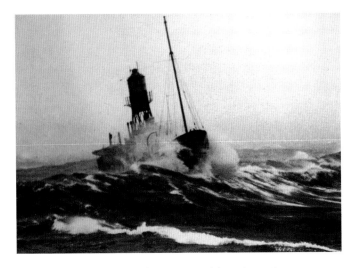

Photographic reference. A useful starting point.

TOOLS USED IN THIS DEMONSTRATION

- Palette (plate) with water/oil-soluble paints
- Boiled linseed oil
- Kitchen roll
- Palette knives
- Soft household brushes
- Mounting board (cream)

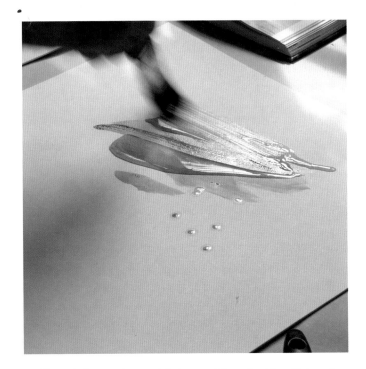

Linseed oil poured on and dark green/blue mixed in with broad strokes. This sinks and disappears almost immediately.

After three repeated applications (which can be done one after another without waiting for each coat to dry) the paint finally stays on the surface and is still fluid enough to move around with a palette knife.

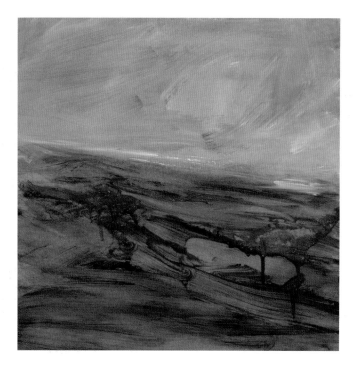

Oil and paint begin to form very fluid marks on their own accord.

These can be smeared and blended, if too coarse.

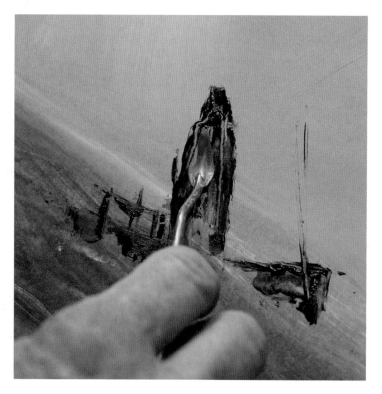

First suggestion of the buoy. Only the palette knife will force the paint to
stay in place – a brush would only slide through the oily surface.

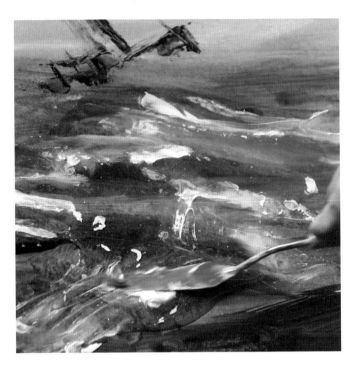

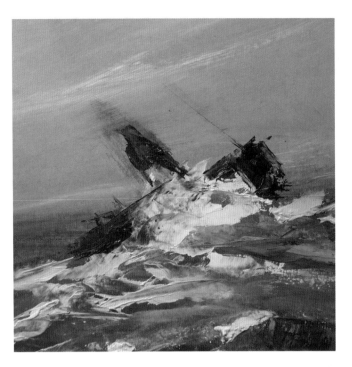

Even more oil added and white paint smeared, which immediately thins and blends and has left behind useful little eddies that we can take advantage of. The more we work the painting, the more mixed and blended the paint becomes, losing some of its immediacy and freshness.

Waves, scooped out with the knife, begin to work together as though driven by a powerful wind. This now accounts for the buoy being forced up as it pulls against its anchor.

Turpentine blown through a diffuser settles on to the wet paint and gently begins to very slightly dissolve it. This has the effect of softening hard edges and gently merging paint. (Give it a chance to work before blowing on more turpentine, or you could find that your painting has bled together and all definition gone. There will be nothing anyone can do to reverse that.)

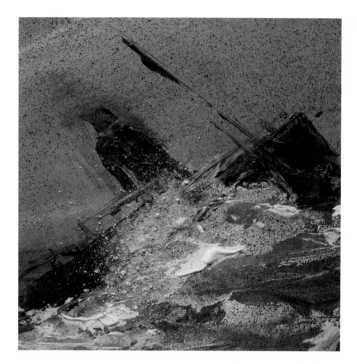

Titanium white powder has been sprinkled from a palette knife to suggest spray being carried by the wind. In some places it will dissolve into the turpentine and become part of the picture.

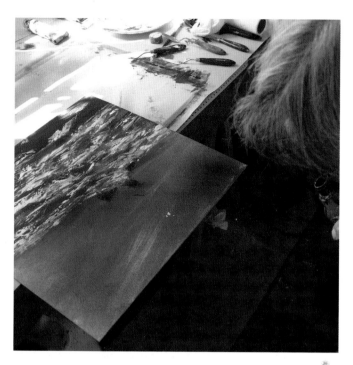

Black ink has now been sprayed on to the sky. As a result the sky has become more moody and the white foam whiter.

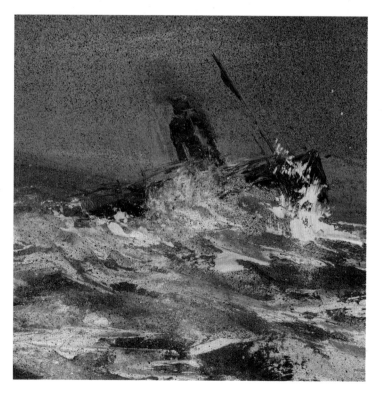

The tiniest sliver of rust red has been added to the buoy, but even that tiny sliver 'reads'. It is the only earth colour in the whole picture.

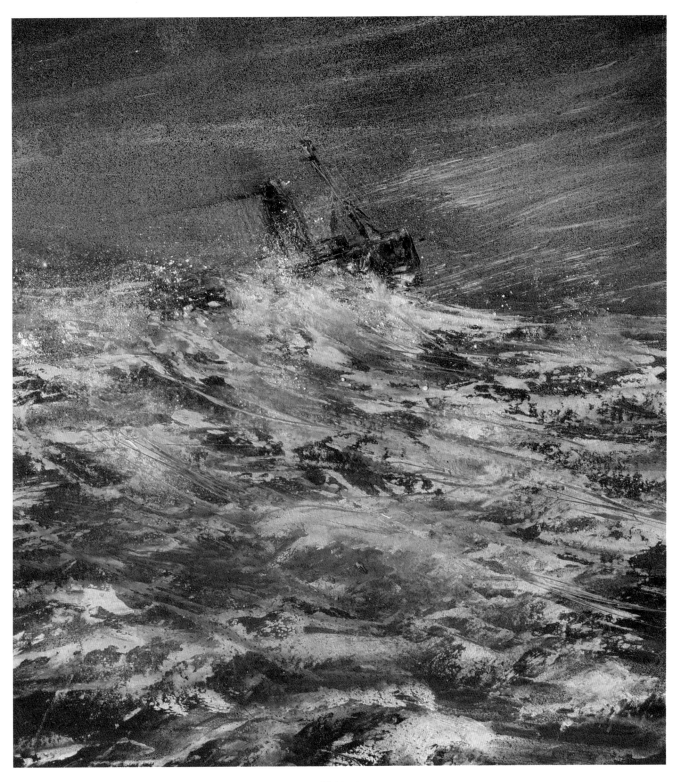

Finished.
The story is of a patient, solitary marker buoy holding its own in a relentlessly pounding sea.

Painting Oil on Board

The following photos show the priming of a board when you know in advance what it is that you want the eventual painting to look like. The piece of hardboard, in this case, is 45 × 60cm and 3.2mm thick. It is smooth on one side and textured on the other (rather like the back of a digestive biscuit): I have seen some paintings that have used this side of the board as it could be felt that it had the feeling and texture of canvas, but I don't think that it is a very pleasing surface to paint on.

The PVA needed for priming can be bought at an art supplier or a builders' merchant. I have never been able to tell any difference, if there is any, but bought from a builder it will be a great deal cheaper.

The last coat goes on while the previous coat is still tacky. This is the final coat, so darken or lighten where it would suit the painting to do so. Try for a really smooth surface.

Even though we haven't actually started painting yet, this preparing of the board will have a lot to do with how the finished painting looks. This painting is going to be nearly all sky. As I have a blue background to start with, then if for example I am painting a cloud and make a big sweep of white, but find the brush has run out of paint too soon, it will be blue that shows through, not brown. This means that I can leave it as it is and not have to go back and add secondary strokes that might take away its immediateness.

On the textured side, two heavy stripes have been painted on diagonally. This will help keep the board flat if the PVA painted on the front side attempts to curl the board forward as it dries.

Paint PVA on the smooth side. Add a little dark blue acrylic to the PVA and about 10 per cent water to thin it, before painting in criss-cross strokes. PVA is white when wet but transparent when dry. The coats dry quickly and, as the PVA is now transparent, there is hardly any blue pigment showing, because you can see the fawn colour of the board showing through as well, now the primer has a green hue to it.

Paint the next coat (from the same pot), this time with long sweeping strokes getting it as smooth as possible. Paint this coat when the previous coat is dry. Add a little white acrylic to the PVA this time and this coat will dry quite blue.

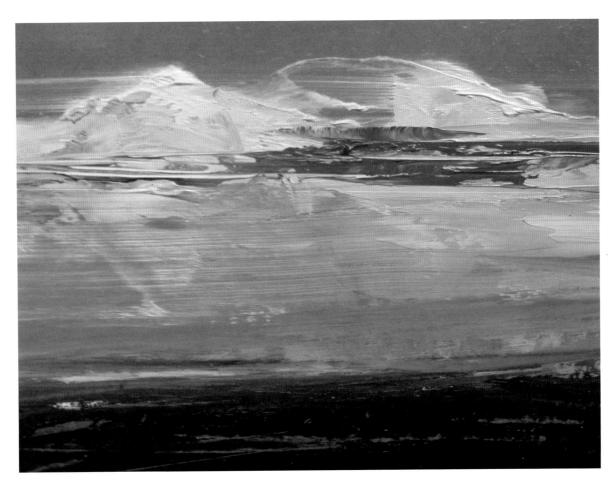

The horizon has been masked with tape. I have never been able to get a reliably horizontal line by freehand. The dark foreground is smeared in with black and Prussian blue, leaving a sliver of ochre and an even finer sliver of yellow. The first bank of distant clouds has been thickly smeared in with a palette knife and a heavy band of rain cloud imposed on top.

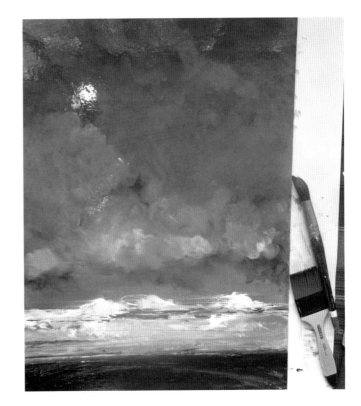

In an effort to make the clouds appear more distant, I tried to soften the edges by blowing neat turpentine at them through a diffuser, masking the foreground by lightly pressing in a sheet of kitchen roll.

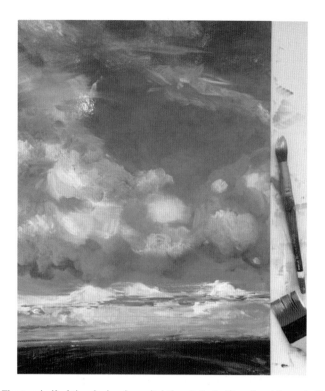

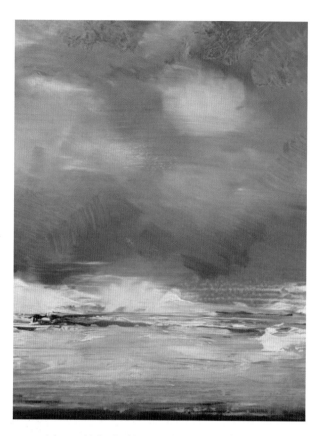

The top half of the sky has been lightly painted with refined linseed oil so that the new clouds will be able to slip and slide around, making them appear more 'wispy'. The darker underside is put in with a big, soft round-headed brush.

A heavy blob of white put on with a round brush.

Close-up.

To 'fuse' the paint and to try to dissolve the very apparent brushstrokes, I tried again with the diffuser but this time the effect was much more dramatic, far more than I intended, and almost spoiled the painting. A 5cm flat watercolour brush was dragged as delicately as possible over the clouds. The turpentine film is cleaned off the sky between the clouds.

There seemed to be so much going on in this painting that the eye just slithered around and couldn't settle. Masking, as is so often the case, concentrates and quietens a painting, and makes it more intelligent. Most importantly, the edges of the painting have been cleaned up. Brush marks in a painting are definitely influenced as they approach the sides of painting. By masking the painting it looks as though the painting carries on past the edges, which of course it does, but under the tape. Also, taping in this way can give an idea of how it might look framed.

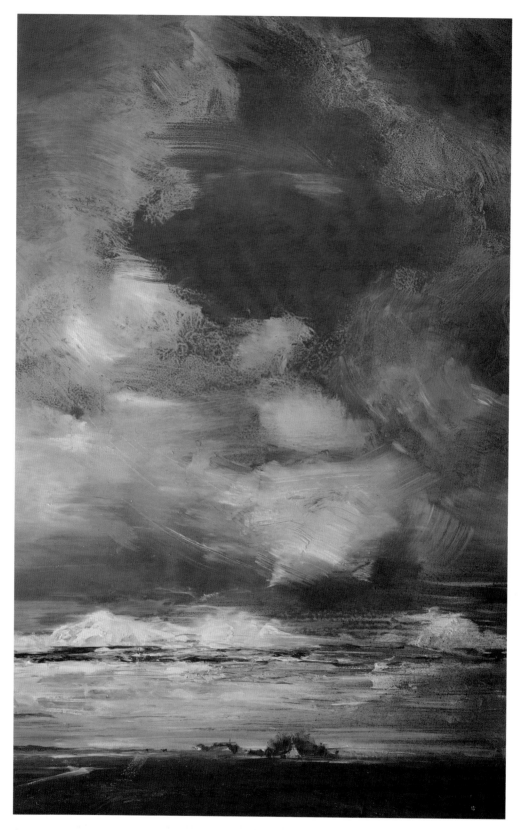

Farm buildings have been added and this has changed the whole picture. It is a curious mixture of intense small detail and huge, amorphous airiness; but this is how the scene appeared on a late autumn day on the Borders. The picture could be cut in half and may even have worked better; however, it is really not a portrait of a farm on the Scottish borders but more a recognition of the extraordinariness of seeing how things often are.

JO BEMIS

For the past ten years my painting has been a direct response to my love for, and affinity with, the sea. I am especially drawn to the north Atlantic coastline, with its rolling waves and luminous quality of light. However, being based on the Isle of Wight means I am never far from a stretch of coastline. My paintings derive from a combination of oil or chalk sketches, photography and, most of all, hours of observation in all different weather conditions. Looking closely at tidal movements, foam patterns and various wave formations is all part of the process.

When outside, I often use chalk pastels to sketch with. This enables me to gather references for colour and tone quickly, without the need to carry oil paints with me. I work rapidly with the chalks, and feel they give me a freedom of expression that is consistent with the subject. These studies will be more true to life than a printed photograph.

Smaller paintings on canvas panels are often composed from memory, using a palette knife and my finger. These are usually experimental and I use them, as well as the chalk sketches, to develop new ideas. Sometimes these paintings derive straight from a chalk pastel drawing.

With the larger paintings, I take a long time to consider the composition, and deliberately confine the painting solely to sea and coast, or just sea, so there are no other distractions. I have to say that I never follow any techniques for making up a composition. There are useful write-ups on this aspect of sea painting, but I tend to go with my own intuition when considering if a painting looks balanced or not. My initial wave sketches are drawn on paper with charcoal, and are very rough, and impressionistic. I then re-draw the sketch and build it up with the relevant colour in chalk.

Before I begin painting, I will sketch out the composition with charcoal on the canvas, and then refine it. I always use a good-quality canvas, stretcher bars and oil paint. Generally I build up the painting in layers, until the desired effect is reached, always using a limited colour palette. The use of painting mediums is restricted to a little refined linseed oil. A painting may take several weeks to complete; sometimes, if I am not happy with how it is working out, I will leave it for a month or two before looking at it again. When seeing it with fresh eyes, it is usually easier to see where I'm going wrong.

The spirit and power of the sea offers endless inspiration for me. It is a wonderful subject to explore in paint.

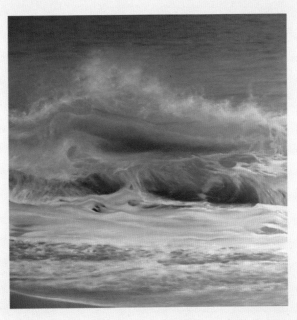

Jo Bemis, **'Turquoise Wave'**. 100 × 100cm. Oil on canvas.

This painting was a result of visiting a surfing beach in Cornwall. As the tide reached its highest point, I noticed a sudden building-up of huge waves rolling toward the shore, almost in slow motion. The waves were breaking very close to the water's edge, and they were incredibly dramatic, with beautiful details through the body of the wave at the point before they broke. The whole performance only lasted for about forty minutes, and then they started to diminish in size. This type of wave is often the result of storms far out to sea. I used rapid charcoal sketches to get a feel for the details inside the waves, and also took some photographs thst helped me get the basic shape for the composition. The details in the middle and top of the wave were fun to create because such dramatic water offers a multitude of possible patterns.

JO BEMIS (Continued)

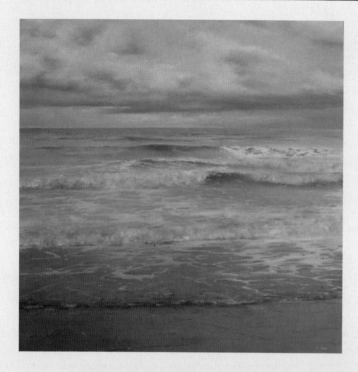

Jo Bemis, '**Yaverland**'. 90 × 90cm. Oil on canvas. *The inspiration for this picture was the incredibly dramatic sky, which evolved after a day of torrential downpours and intermittent sun. I had hurried down to the beach, and was struck by the beautiful pinkish band of light on the horizon, which from experience I know sometimes only lasts a few minutes. I wanted this dramatic lighting effect to be the focal point of a painting, along with the clouds. I tried to make the composition interesting by painting the shallow water from the receding tide toward the bottom of the canvas, so leading the eye through the painting toward the light.*

Jo Bemis, '**Wave in sunlight**'. 60 × 100cm. Oil on canvas.
This wave painting was one of the results of observing them breaking offshore, and was all about trying to show the effects of sunlight on water. I had positioned myself on some rocks off the island at St Ives so I could get a different perspective. It is really important to be aware of the tide if you try this – Atlantic waves in this spot can be really dangerous, and it is not unusual for people to get swept into the water. I added rocks into the painting to try to give the picture a stronger composition. It took me one or two attempts to achieve the effect I wanted. It was very important to get the right tonal balance, especially in the white areas, which are made up of warm and cool colours.

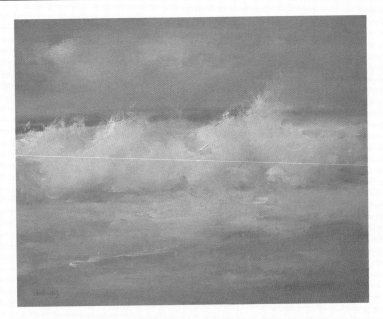

Jo Bemis, '**Morning, Porthmeor**'. 20 × 25cm. Oil on canvas board.

This little oil sketch was made up from memory, after visiting Porthmeor beach at low tide early one October morning and venturing into the icy water in Wellington boots. Although the water was relatively calm in the shallows, it is always surprising how strong the current is, so care must be taken. I took a notebook with me and wrote down the things that caught my imagination, such as the beautiful colours in the water, which seemed to be predominantly cerulean blues, ultramarines and magentas. This is my favourite time of year for observing cloud effects down on this beach, as they often turn a dramatic yellow with pinkish tinges just as the sun reaches a certain point in the sky. This sketch actually took me some time to make, and it must have been several weeks before I was finally happy with it.

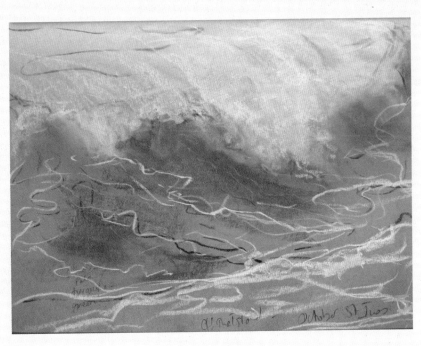

Jo Bemis, Sketches

This sketch was one I made while on the rocks off the island at St Ives. It was a very cold, windy day and not the easiest conditions in which to sit outside, especially on the north Atlantic coast. This is one of the advantages of using chalk pastels and charcoal: they can be used to capture the character and colours of water relatively quickly, before my hands go numb with cold.

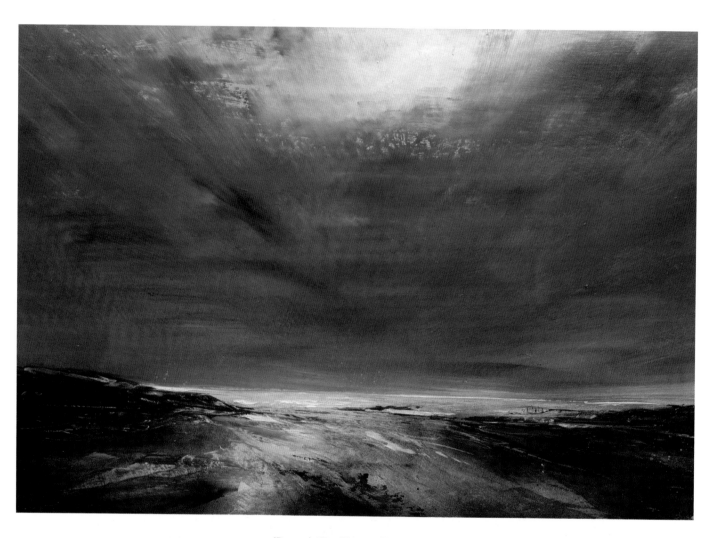

'**Dorset**'. 72 × 85cm. Oil on board.

Painted from a photograph taken a few hours earlier. It had rained heavily all afternoon and I thought nothing could be done that day but, just as I got in the car, the rain stopped and a watery sun struggled through, lightening up the saturated ground. Without the light at the top of the painting the lower part wouldn't have made much sense.

CHARTING THE WEATHER

Our planet is covered in a sensitive film as thin, in comparison, as a coat of varnish on a cricket ball, which diffuses harsh sunlight, softening it and spreading it around by refraction. Clouds, huge water carriers, slide millions of tonnes of water around the planet, collecting it invisibly from one source and distributing it in another – just a most brilliant piece of engineering. Equally as brilliant is the exquisite gait of the earth around the sun at its angle of 23.5 degrees, giving itself periods of night and day, of breathing in and breathing out, of summer and winter, of waking and sleeping.

To paint skies you need to be interested in them, and in what is happening. Which clouds are higher than others? Which clouds are reflecting the sun and so showing where the sun is, even if you cannot see it? How different clouds are when the sun is shining up under them and what the wind is doing to them. How clouds tend to darken in the middle as the light cannot get through. Being aware how very different the blues and turquoises are in intensity in different parts of the sky.

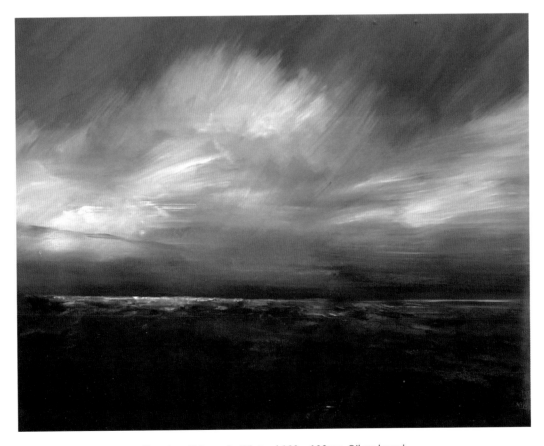

'Evening. Estuary in Winter.' 120 × 100cm. Oil on board.

Painted from the camper van window and finished in the studio that night. A cold, wet spring evening. I just wanted to go home, but once I had started there was no choice but to keep going. I'm glad now that I did: I now have a record of that evening, whereas had I gone home it would have been lost from memory. One of the most pleasing moments in charting the weather is when two completely different weathers are going on in the sky at the same time.

Clouds

I can imagine somebody saying 'I don't really want to paint the clouds naturally. My way of relaying information is a more abstract, more removed and in a less obvious way.' Speaking for myself, I find that the painting of the sea and, in particular, the sky *is* abstract. The great joy of being able to paint skies in an entirely natural and representative way *is* abstract painting. There is no contradiction. Apart from being composed of, and moved around by, the laws of physics, clouds can present themselves in any way they please. The combinations of colour and texture that this gives rise to seems just inexhaustible.

Isn't that the thrill of sky painting?

'Storm Clouds, Dorset'

For our skyscapes to be intelligent we just have to have some feeling for what is happening there. There doesn't seem a lot of value in knowing that those beautiful, wispy clouds overhead are *cirrus castellanus* or *cirrus spissatus* if we can't see that their entire composition is of gently falling ice crystals being taken by winds, or that the massive *cumulus congestus* are boiling up and expanding from the inside, and that it is their sheer density that bounces the light back so strongly and can penetrate only at the extreme edges.

Dark shadow underneath contrasting sharply with the white mass above. All this is going on, plus the shadows they cast on to each other. In between these floating mountains, shafts of sunlight pick out patches of distant landscape, creating a marvellously abstract piece of natural theatre.

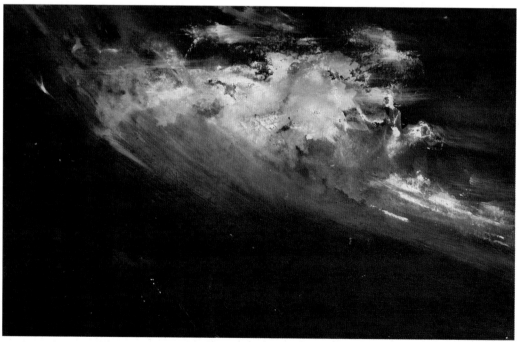

'Night Sky'. 42 × 22cm. Oil on card.
Painted from the studio window as the moon appeared.

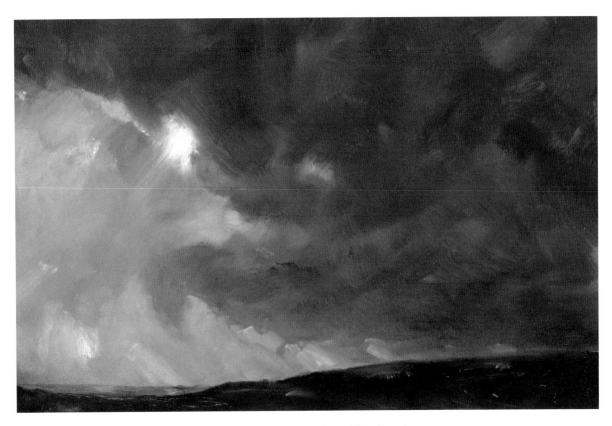

'**Coming Storm**'. 95 × 60cm. Oil on board.
It was so exciting watching these thunder clouds swirling up that I stayed and watched. It was warm and actually a pleasure to get absolutely soaked. They were painted from memory not long afterwards.

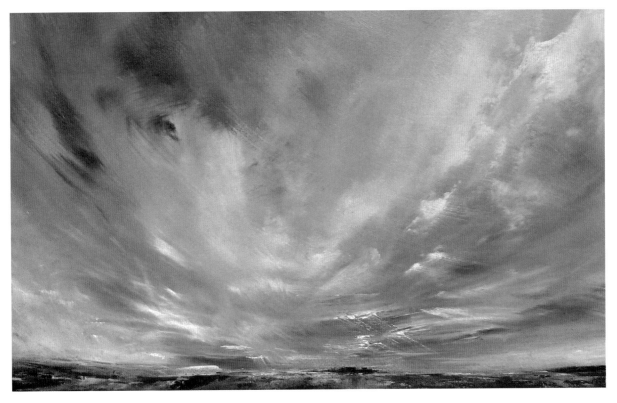

'**Sandbanks, Dorset.**' Oil on board. 110 × 64cm.

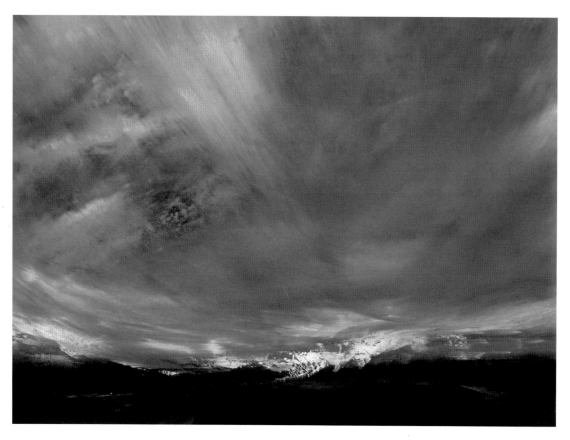

'**Snow, Dartmoor.**' Oil on board. 70 × 60cm.

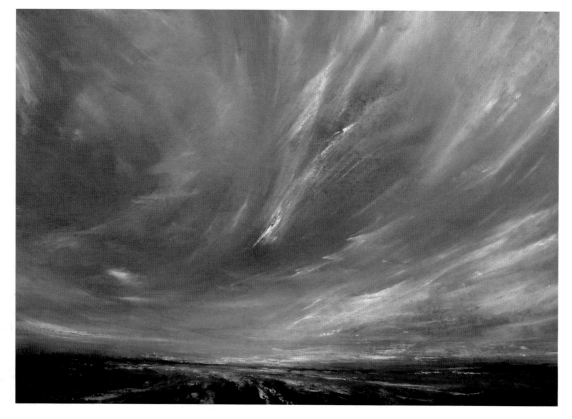

'**Wareham, Dorset.**' Oil on board. 90 × 63cm.

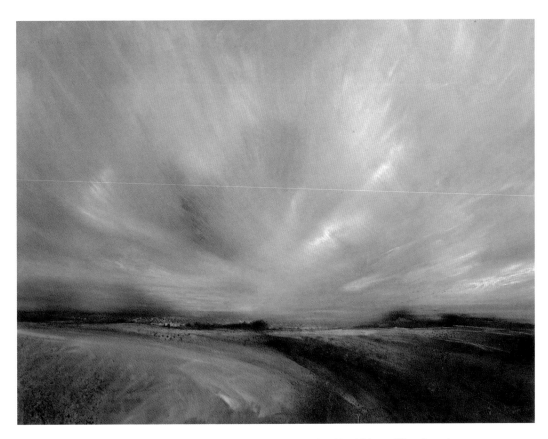

'Winter Fields overlooking Wareham, Dorset'. 170 × 150cm. Oil on board.
Houses were just visible at the far edge of the stubble field.

'Winter Landscape. Clump of beech trees in a ploughed field'. 140 × 110cm. Oil on board.

Before I wrote this book, I would set about painting without much thought about the 'how' and the 'why' of it all. However, in having to describe my methods and approach to painting, in detail, to others I have begun to see for the first time how I work myself.

It has been a great puzzle to me how it is that, in dreams, you sometimes find yourself having to do something like opening a complicated lock or paying out rope from a windlass, and then on waking (if you can remember the dream) you are amazed at your detailed knowledge of something that, as far as you know, you have never seen before and know nothing about. Some part of the brain must have observed these details somewhere and recorded them. My guess is that this is going on in our lives all the time, but that we are not aware of it.

Often in my painting (especially if it is not going well and I am really just trying to salvage it), I just go on fiddling and altering, relentlessly, like a dog with a rag doll, on and on, until something says 'OK. That's close. Leave it now.' This 'something' must be that same part of the brain that knows how things look when they are right. As in the dream, it knows perfectly clearly just how things are.

To sum up, I would say that the way I paint land, sea and skyscapes is to prime the boards in a sympathetic, neutral but lively way and let that part of the mind look and see what it can see there. Then try to work along with what comes up and not question too much. If we also have a good repertoire of mediums, tools and techniques to call on and are not fixated on just one or two, then it is possible to let a picture begin to unfurl itself.

We have more going for us than we may think.

Also, we always have our skill and experience to bring the painting around if it seems to be drifting or going nowhere. This means being very alert but at the same time not trying to dominate. A kind of listening and a 'getting out of the way'. A phrase I heard recently that keeps coming back is 'We become deeply responsible when we get out of the way.'

The three paintings here and opposite above were started between 5 o'clock and 9 o'clock in the evening with the easel set up on the sand at Sandbanks in Dorset. It was a wonderfully calm evening, with no wind to rattle the easel or throw dry sand into the wet paint. No dog walkers to come and chat.

Most of these paintings were done on site, although many of them were finished later in the studio. Some of the most interesting are those painted just after heavy rain, as everything glistens. Skies try to clear themselves up (like a child getting over a tantrum).

This is where a camper van or similar is so crucial. You can pick your moment.

'After Heavy Rain, Sandbanks, Dorset'.

'**Night Scene. Dorset**'. 130 × 112cm. Oil on board.
Finished in the studio.

'**Summer Night, Iceland**'. 125 × 110cm. Oil on board.

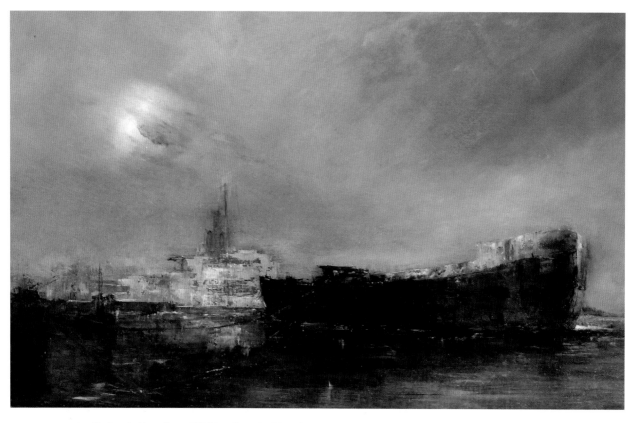

'Iceland. Abandoned Fishing Boat and Herring Processing Factory.' 110 × 64cm. Oil on board.

Abandoned when the herring moved their breeding grounds, just after the Second World War. A wonderfully desolate scene: everything just left; slowly and surely the mud and the sea digests it into itself, back to where it came from in the first place. Rusting ships are quite beautiful – such lovely warm colours, so much purposeful engineering becoming almost organic.

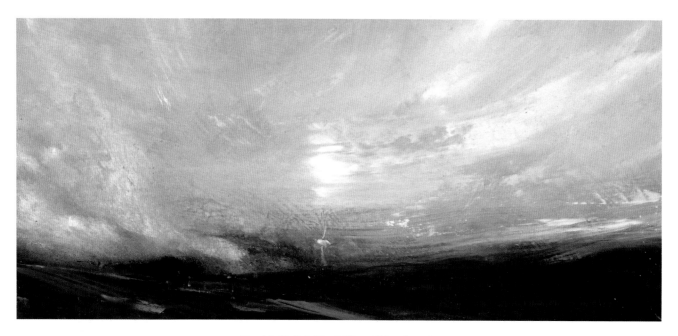

'Double Helix'. 35 × 103cm. Oil on board.

A Double Helix – also called Sun Dog or Parhelion – is caused by ice crystals refracting the sun. I didn't know this when I painted it and I was tempted to edit it out, thinking it would look like a mistake. Then I remembered that I no longer allowed myself to interfere with what is there. If it's there it must be right (because it's there).

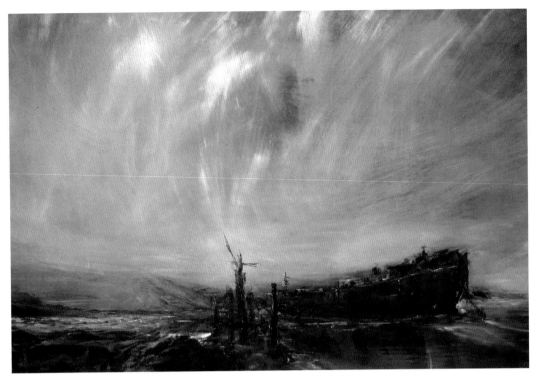

'Abandoned Herring Boat, Iceland'. 112 × 70cm. Oil on board.

Another of these great abandoned ships, Iceland's 'Marie Celestes'. The mud was too soggy to do anything but take photographs and too dangerous to climb aboard: some apparently solid-looking panels simply turned to dust at the touch. Painted sometime later.

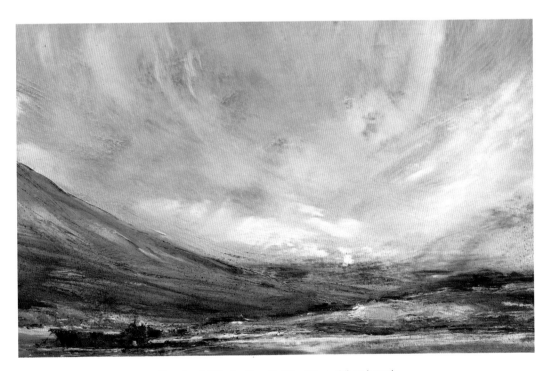

'Rusting MTB. Scotland'. 90 × 52cm. Oil on board.

I was surprised to come across this Second World War Motor Torpedo Boat whist hiking in Scotland. It looked as if somebody had once lived in it, but was now completely abandoned. It was painted from sketches done on a piece of scrap paper since I had no intention of drawing or painting on this walking holiday. Very atmospheric: I didn't feel that I should disturb a thing.

PETER ARCHER

I always have something definite in mind to start with. At this stage a finished painting exists in my head. Using paint from the beginning – no drawing or studies, and no photographs – I set about bringing that initial image into being. The first attack with the paint is really about establishing the main lines of the composition, finding the major divisions and areas on the canvas. Decisions are made standing back from the canvas: this way you can take in the whole rectangle. This seems to me very important because painting, as I practise it, is both an abstract proposition and an attempt to make a convincing reality. However, as the painting continues the original idea gets left behind and I find myself responding more and more to what is coming out of the marks, from the paint itself. If I'm lucky something more satisfying than the first thought emerges; I imagine that Turner, for instance, worked at times in a similar way.

A big part of why I have been doing a lot of sea pictures over the last few years is, I think, because it allows me to swish the paint about in a way that did not seem possible when painting landscape, for instance. I use oil paint on canvas, occasionally on board, diluting the paint with artist's turpentine and then adding a little linseed oil as the paint builds up. This is a basic rule for oil paintings: start lean and bit by bit use fatter (more oil-rich) paint. This prevents cracking and dried-out surfaces. Oil paint can be put on in many different ways: with a brush or knife, or smeared on with a rag. It can be used as an impasto alongside thin washes. Painting the sea, in particular, in the way I have described seems to me to demand a boldness of approach and not being frightened of getting in a mess with the picture. By not being intimidated you will emerge from that mess to something stronger. Every painting I make goes through several crises!

I realize that this is very much a method of working that has no safety net. The important thing is to be bold and push yourself beyond what you believe you are capable of.

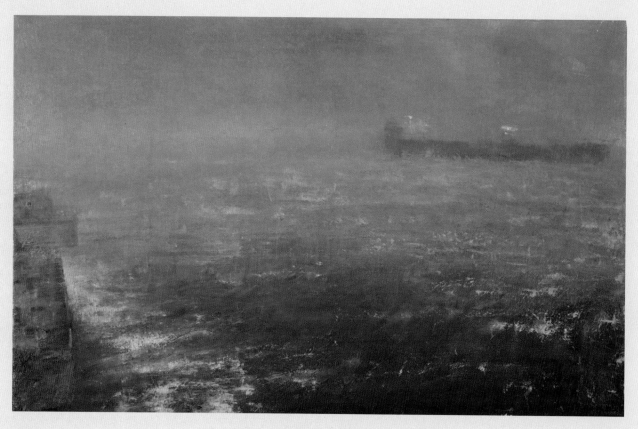

Peter Archer, '**Dirty Night 2005–12**'. 120 × 180cm.

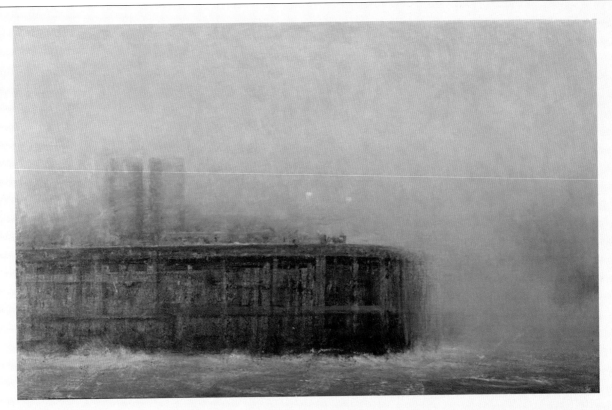

Peter Archer, '**Concrete Jetty 2011–12**'. *75 × 120cm.*

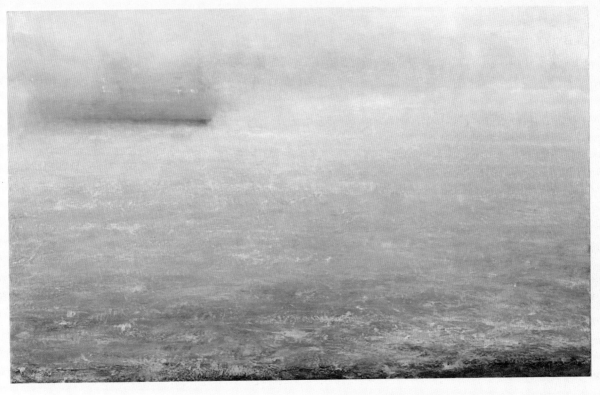

Peter Archer, '**Turning Vessel**', *75 × 120cm. Oil on canvas.*

PETER ARCHER (Continued)

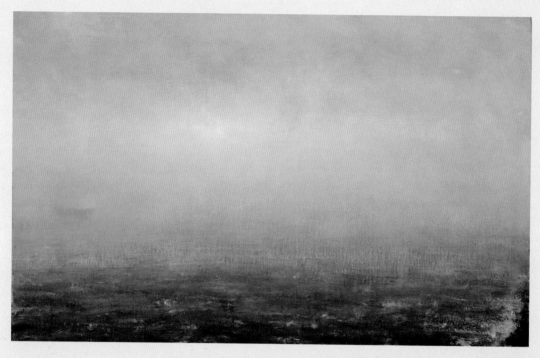

Peter Archer, '**Faint Vessel**'. 75 × 120cm. Oil on canvas.

Peter Archer, '**Looking Down, Inlet 2011–12**'. 90 × 120cm.

Peter Archer, '**Bay 2012**'. 90 × 120cm.

Peter Archer, '**Dark Coast**'. 70 × 100cm. Oil on canvas.

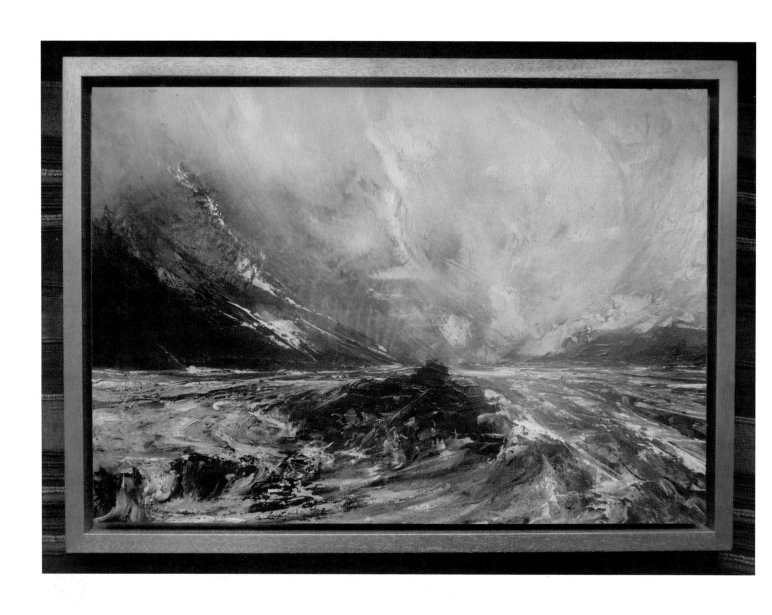

USING A TRAY FRAME

A 'tray frame' is frame for a painting that has been done on board and that appears to 'float' inside its frame. It is very simple and very effective; it can feel surprisingly generous since there is not much decoration to it.

I had an exhibition of twenty four large paintings, all on board. The cost of framing these would have meant that I would have had to sell over a quarter of them to cover the quoted cost from the framer. However, he pointed out the making of the simple double frame that each picture required wasn't where the time was spent, but in screwing the two frames together. Each frame needed thirty-two small screws in eight small plates to do this: the cost of frames was halved by my asking if I could do this screwing myself back at my studio.

It took quite some time but it isn't unpleasant work.

Reducing the cost like this took the urgency and stress out of needing to sell well. It also enabled me to lower the price and so increase the chance of selling more. (In this particular case, only a few paintings sold at the private view, a few more sold over the course of the exhibition, and the rest have been very slowly trickling out since.)

EXHIBITING

My own approach was to frame the paintings in a way that I liked but that didn't cost a huge amount. Others are much more adventurous in this respect, but the pressure that it puts on the need to sell well, to recoup the outlay, is obvious. Wait until you are certain that they sell well before going to town on the framing.

If you have an agent then they well might help with the cost, as might the gallery. On the whole, it is best to stand back and let them decide: they know their business and are not so involved with the paintings themselves as we are. This goes for the pricing of them too.

Something else to bear in mind is that if you have sold successfully then the chances are that your agent or gallery will be keen for you to produce more of the same.

'So?' I hear you say.

If doing that suits you then that is going to be good news, but not if you want to keep experimenting.

Everybody's story is different and yours is as good as anyone's. Think of Van Gogh.

Looking at his early drawings, who of us would have bet on him to go on to become the great light in world painting.

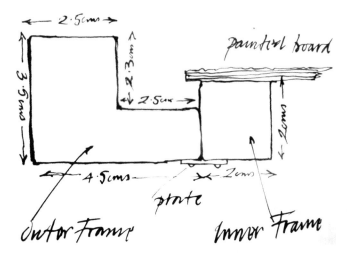

Frames don't necessarily have to be of the measurements quoted here, but depend more on the sizes that are cut by the factory.

The two frames inner (fine) and outer (heavy) and one of the eight small brass plates that secures them together.

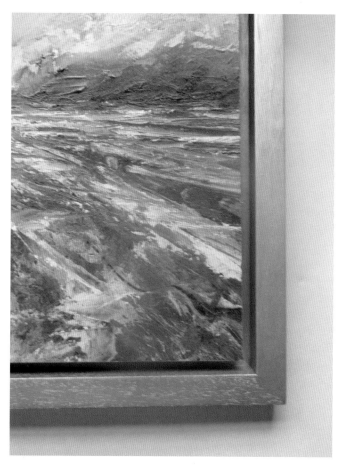

The frame was sprayed silver and a blue wash run round the inner edges. Obviously you can change the colour according to the picture going in it. The painting on board is glued in place with PVA, and heavy books placed on top around the edges for twelve hours or so.

The two frames shown from the front. The inner frame stands proud.

INDEX

*Page numbers in **bold** relate to artist features.*

RELATED TITLES
FROM CROWOOD

The Art of Chinese Brush Painting

MAGGIE CROSS

ISBN 978 1 84797 289 7

208pp, 320 illustrations

Drawing and Painting Insects

ANDREW TYZACK

ISBN 978 1 84797 489 1

192pp, 540 illustrations

Botanical Illustration

VALERIE OXLEY

ISBN 978 1 84797 051 0

192pp, 220 illustrations

Drawing and Painting People

EMILY BALL

ISBN 978 1 84797 088 6

144pp, 200 illustrations

Drawing and Painting Birds

TIM WOOTTON

ISBN 978 1 84797 224 8

160pp, 420 illustrations

Painting Boats and Coastal Scenery

ROBERT BRINDLEY

ISBN 978 1 84797 119 7

176pp, 225 illustrations

RELATED TITLES
FROM CROWOOD

Painting Landscapes in Oils

ROBERT BRINDLEY

ISBN 978 1 84797 314 6
160pp, 260 illustrations

Painting with Oils

DAVID HOWELLS

ISBN 978 1 84797 715 1
112pp, 110 illustrations

Painting Landscapes in Watercolour

PAUL TALBOT-GREAVES

ISBN 978 1 84797 085 5
176pp, 200 illustrations

Wildlife Artists' Handbook

JACKIE GARNER

ISBN 978 1 84797 607 9
176pp, 260 illustrations

Painting Portraits

ANTHONY CONNELLY

ISBN 978 1 84797 264 4
112pp, 180 illustrations

In case of difficulty ordering, please contact the Sales Office:

The Crowood Press
Ramsbury
Wiltshire
SN8 2HR
UK

Tel: 44 (0) 172 520320
enquiries@crowood.com
www.crowood.com